General Editor
David Piper

Bosch
Every Painting

Germano Mulazzani

translated by Jane Carroll

RIZZOLI
NEW YORK

Foreword by the General Editor

Several factors have made possible the phenomenal surge of interest in art in the twentieth century: notably the growth of museums, the increase of leisure, the speed and relative ease of modern travel, and not least the extraordinary expansion and refinement of techniques of reproduction of works of art, from the ubiquitous colour postcards, cheap popular books of colour plates, to film and television. A basic need – for the general art public, as for specialized students, academic libraries, the art trade – is for accessible, reliable, comprehensive accounts of the works of the individual great masters of painting; this has not been met since the demise before 1939 of the famous German series, *Klassiker der Kunst*; when such accounts do appear, in the shape of full *catalogues raisonnés*, they are vast in price as in size, and beyond the reach of most individual pockets and the capacity of most private bookshelves.

The aim of the present series is to provide an up-to-date equivalent of the *Klassiker* for the now enormously enlarged public interested in art. Each volume (or volumes, where the quantity of work to be reproduced cannot be contained in a single one) catalogues and illustrates chronologically the complete paintings of the artist concerned. The catalogues reflect as far as possible a consensus of current expert opinion about the status of each picture; in the nature of things, consensus has yet to be reached on many points, and no one professionally involved in the study of art-history would ever be so rash as to claim definitiveness. Within the bounds of human fallibility, however, every effort has been made to achieve both comprehensiveness and factual accuracy, while the quality of reproduction aimed at is the highest possible in this price range, and includes, of course, colour. Every effort has also been made to hold the price down to the lowest possible level, so that these volumes may stay within the reach not only of libraries, but of the individual student and lover of great painting, so that they may gradually accumulate their own 'Museum without Walls'. The introductions, written by acknowledged authorities, summarize the life and works of the artists, while the illustrations place in perspective the complete story of the development of each painter's genius through his career.

David Piper

Introduction

'There are also some panels of various strange scenes, simulating seas, skies, woods and many other things . . ., things which are so pleasing and fantastic that it would be impossible to describe them properly to those who have no knowledge of them.' This is how Antonio de Beatis described Bosch's *Garden of Earthly Delights Triptych* (No. 28) in 1517. He had seen it in Brussels in the palace of Henry III of Nassau, Regent of the Netherlands, during his visit there in the entourage of Cardinal Luis of Aragon. This is the earliest description known to us of a work by Bosch, and it tallies with the opinions expressed in a number of other early writings, which all refer to him above all as a creator of unusual and astonishing forms.

This fame is indirectly confirmed by the innumerable copies which were made of the 'fantastic' paintings, from his own lifetime onwards. The rather superficial idea of him as a painter of fantastic images is still the one which comes to mind most readily, despite the work of scholars over many years who have tried to correct this commonplace. They have pointed out the specifically pictorial values discernible in Bosch's style and compositions, the deep and complex ties between his work and the culture of his time, particularly the Flemish artistic tradition to which he belonged, and they have tried to explain the real meaning of his more fantastic paintings which appear to be so free of any formal considerations of content and composition.

However, the traditional image of Bosch persists, while the question marks and corresponding theories seem to have multiplied with the mass of literature which has been published on him. The difficulty of building up a satisfactory picture of the painter, whose greatness has never been in doubt, lies partly in the lack of documentation on his life and works, and partly in the way in which modern critics have approached him.

The catalogue of Bosch's works was established in the studies by Justi (1889), Dollmayr (1898), Friedländer (1927), Baldass (1943) and in Tolnay's fundamental monograph (1937). The catalogue is by now definitive in its overall coverage but is continually being amended in its details. Modern studies have to an increasing degree concentrated on the problems surrounding the iconography used by Bosch. The most recent monographs, by Combe (1959), Reuterswärd (1970), Linfert (1972), Gibson (1973) and Schuder (1976), as well as most of the more specialized studies, such as those by Gombrich (1967 and 1969), Glum (1976), Lindberg (1972) and Gibson (1973), to mention only a few, have aimed at trying to throw light on the puzzle presented by Bosch's themes. Although their findings are far from unimportant, there is nevertheless a risk of widening the painter's cultural horizon to such an extent that he loses any credible identity. In trying to explain the many anomalies and obscurities in Bosch's work, scholars at various times have referred to the individual and collective unconscious, the anxieties concomitant with contemporary religious currents, the concepts and images found in fourteenth and fifteenth century mystical literature, the upheavals of a society undergoing rapid transformation, themes borrowed from alchemy, astrology and from the speculations of heretical sects, motifs from popular lore and magical formulas. These many and varied explanations cannot coexist; or at least they do not make sense if applied at one and the same time.

The task that now needs to be carried out by scholars seems instead to be that of trying to achieve an overall picture of the artist and his work which covers stylistic and compositional considerations together with the iconographical aspects. This composite picture could be built up on the basis of the following studies: those which have attempted to throw light on Bosch's artistic career (e.g. Slatkes, 1975; K. G. Boon, 1960 and 1968); those dealing with contemporary criticism of Bosch's work and the criticism of the generation immediately following him (Kurz, 1967; Unverfehrt, 1976); and, of the strictly iconographic studies, those which have managed to limit the range of suggested sources to credible proportions.

Difficulties of a more objective nature arise out of the lack of information and

documents relating to Bosch. He appears to have led a very withdrawn, uneventful life in 's-Hertogenbosch, one of the main cities in northern Brabant. He was born there, probably around 1450, and took his pseudonym from the short form of the city's name (which is still in use in Holland). His real name, Jeroen Anthoniszoon van Aken, reveals his family's origins, many years earlier, in Aachen. The family, mentioned in the municipal records of 's-Hertogenbosch (Bois-le-Duc in French) from the early part of the fifteenth century onwards, included many painters. To Jan van Aken, Jeroen's grandfather, is attributed a fresco of 1444 in the city's cathedral showing a Crucifixion. His father, Anthonis, and his uncles Goossen and Thomas, were also painters and it was from them that Jeroen must have had his earliest training.

In about 1478 Bosch married Aleyt van de Vervenne, daughter of a well-to-do nobleman: this probably gave him enough financial security to allow considerable freedom in his artistic activity. Jeroen (or Jheronimus, as he signed himself, Latinizing his name) is mentioned in several documents connected with his wife's business affairs (1483, 1487, 1488, 1494, 1498). These, together with the records of the Brotherhood of Our Lady (Onze Lieve Vrouwe Broederschap of s'-Hertogenbosch Cathedral, to which he belonged from 1486 until his death in 1516, are the main sources of documentation on the artist. The Brotherhood records mention him in the years 1488, 1493–4, 1498–9, 1503–4, 1512 and 1516 (for the last year there is a record of the funeral of '*Jheronimus van Aken alias Bosch, insignis pictor*'). Scholars have attached considerable importance to his membership of this Brotherhood. Influenced by the Brothers and Sisters of the Common Life, it was part of that far-reaching and profoundly felt religious movement known as the *Devotio Moderna* which spread through the Netherlands in the fourteenth and fifteenth centuries, anticipating in many ways the themes and emotions of the Reformation.

Of the few documents relating to Bosch's artistic activity, none is connected with any of his surviving works. For the cathedral of his native city he painted (between 1489–90 and 1491–2) the back of the wings of his Brotherhood's altarpiece. Also for the Brotherhood's chapel he supplied, in 1492, the design for a stained-glass window. In 1504 he was commissioned to execute a *Last Judgement* (identified, debatably, as No. 48) by Philip the Fair, Archduke of Austria and brother of the Regent of the Netherlands. These few pieces of information are supplemented by other scraps of documentary evidence dating from after the painter's death but which indirectly throw some light on one aspect of his work: the very important subject of the public for whom Bosch produced his paintings which, from their size and subjects, appear to have mostly been made for private individuals. There are a number of significant indications of the high degree of appreciation which Bosch enjoyed, especially among the aristocracy. For example, it is known that in 1516 Margaret of Austria, sister of Philip the Fair, owned a picture by Bosch (an unidentified *St Anthony*); in 1517 the famous *Garden of Earthly Delights Triptych* (No. 28) was in Brussels in the palace of the new Regent of the Netherlands; three other paintings were in the possession of Cardinal Grimani in Venice in 1521; and finally tapestries were made from the *Garden of Earthly Delights Triptych* for Cardinal Granvelle and for the Duke of Alba. Another point worth noting is the success his works had at the Spanish court which in 1570 purchased the pictures of the Guevara collection, which we know to have been already formed by 1520. The presence of Bosch's paintings at the Spanish court is also a serious argument against any tendency to see in them themes which are highly esoteric or even heretical in relation to the society and religion of his time.

Any attempt to construct an overall picture of Bosch and his work on the basis of this rather sparse collection of documentary evidence must also take into consideration the reasonable hypothesis (Slatkes, 1975) that the painter made a journey to Italy, sometime between 1499 and 1503. For these years there is no mention of Bosch in the records of his native city. Moreover, several major Italian artists (Raphael, Leonardo and Giorgione) and other artists active in Italy in that period (e.g. Dürer) borrowed motifs from Bosch's unmistakable figurative repertoire. Venice has been named as the principal goal

of that journey. It is surely not by mere chance that there is contemporary evidence that a number of Bosch's works were in Venice in that period and that others (maybe the same works) are still preserved there (Nos. 30, 31, 32). Another significant fact is that at about that time (1499–1503) the painter began officially to call himself by the pseudonym Bosch: this use would not make sense if the artist had never left the place. For years his family had been known by the name of its original home town, and the first document recording his new name is in fact dated 1504.

The theory merits careful consideration not only for its basic implications but also because it highlights another factor, namely the extent to which Bosch's work was known and disseminated outside the Netherlands. The fact that some of the greatest European artists soon took up some of his themes destroys the myth of his artistic isolation. It also suggests that his training had had a wider base than is often supposed, although this is a subject which is surrounded by uncertainty.

However, this is another traditional view which has gradually been altered: the idea of Bosch as an artist without roots, who suddenly burst into life in a provincial environment without an artistic tradition of any importance. The city of 's-Hertogenbosch belongs to the cultural world of Flemish painting which, as is well known, is hard to distinguish from true Dutch painting throughout the whole of the fifteenth century.

In 1433 Holland came under the sovereignty of the Dukes of Burgundy. Political unification led to a similar move in the artistic sphere, with a number of painters moving to Holland. First of all was the leader of the early Netherlandish school, Jan van Eyck, who was active at the Dutch court at The Hague in 1422–4. However, scholars of Netherlandish painting all agree in recognizing in it a certain autonomy of expression, especially in its greater sensitivity towards the pathetic and the sentimental. This arose from the strong influence in Holland of the *Devotio moderna* movement. Haarlem was an artistic centre particularly affected by the movement, beginning with the Master of the *Virgo inter Virgines* and Geertgen tot Sint Jans, who was the school's major exponent. It is difficult, however, to place Bosch, in his earliest period,

within the context of this school of painting, just as it is difficult to associate him with any of the other centres of Flanders, such as Bruges, Ghent, Brussels or Louvain. The clearly archaic nature of his early works does in fact recall the sources of the new Flemish painting: the Master of Flémalle and Jan van Eyck, or else some little-known earlier figurative models found in miniatures and popular prints.

All this is less inexplicable if we place Bosch, as seems reasonable, alongside the other great European masters who flourished between the end of the fifteenth and the beginning of the sixteenth centuries. These artists in general made a great qualitative leap forward from traditional painting, although the latter continued to exist during their period of activity and after. Against this background we see that Bosch made numerous innovations, some successful, others less so. Among the more external of these innovations is his transformation of subjects normally confined to the world of popular art. It has been rightly pointed out that artists were acquiring a new role at this time, but their early careers, like that of Bosch, are bound to remain more or less in obscurity. In his case, the problem is complicated by the difficulties of ascertaining authenticity and of dating.

None of Bosch's paintings is dated. Few (Nos. 21, 30, 32, 43, 62) carry signatures which are not regarded as apocryphal and the documentation, as we have seen, tells us nothing about the surviving works. Tolnay's division of his works into three main conventional periods (youth, maturity and old age) still carries weight, but many important doubts have since been voiced about the chronology of the individual paintings. The establishment of a definitive catalogue has been made more difficult by the great number of copies which in many cases are all that remain of lost originals.

Tolnay's scheme of three main periods does make sense as far as Bosch's use of themes is concerned but it does not sufficiently explain the artist's stylistic and expressive development. From this point of view a division into two main periods seems more plausible, with a fairly clear break in the very early years of the sixteenth century, probably

arising from the painter's stay in Italy.

Scholars generally agree about the early works, dating from about 1474 to 1485. This group includes: *The Cure for Madness*, in the Prado (No. 1), *The Seven Deadly Sins* (No. 2), also in the Prado, *The Marriage at Cana*, in Rotterdam (No. 3), the *Adoration of the Magi*, Philadelphia (No. 8), the Brussels *Crucifixion* (No. 9) and the Frankfurt *Ecce Homo* (No. 10). It has been said that Bosch already shows in these early paintings that he has a well-defined personality and that what were to become his most typical themes are already introduced. The moralistic and didactic aim is recognizable not only in the meaning of the non-Biblical compositions like *The Seven Deadly Sins*, *The Cure for Madness* and *The Conjuror*, but also in the actual handling of the themes. *The Seven Deadly Sins*, the only one of these works to have come down to us whole (while the others are probably fragments or sections), illustrates the sins in a series of scenes within a circular composition at the centre of which is Christ encircled by rays. This is the visual realization of the concept expressed ('*Cave, cave, dominus videt*'): in other words, divine omniscience. All this is framed, as in a domestic, *summa theologica*, by the representation of the Four Last Things (death, last judgement, hell, paradise), a constant reminder of the inescapable end of all things human. Similarly, the subject of human folly is already present in these early paintings: *The Cure for Madness* and *The Conjuror* are ferocious satires on human stupidity which is easy prey to trickery, while the works with Biblical subjects, such as *The Marriage at Cana* and *Ecce Homo*, illustrate another recurrent theme, that of the eternal conflict between good and evil and, in the *Ecce Homo*, also the subject of the sufferings of the just.

Nevertheless it must be said that the means of expression used in these early paintings is still vastly undeveloped compared with those of the subsequent works. In the early group, Bosch shows a propensity for anecdote, almost in *genre* style, obtaining his figurative sources in motifs and compositions of pre-Eyckian realism. This tendency was gradually to disappear in the later works, in which Bosch took a single episode and inserted it in an almost cosmic scheme, so that it lost its narrative character and became a timeless symbol. On the other hand it is important to emphasize that from the outset Bosch did make use of an extensive but definite range of themes, making himself interpreter of religious and cultural issues which until then had been ignored by artistic iconography. We do not know the basic reasons for Bosch's choice of themes, although the background has been thoroughly investigated in various studies (including in particular Huizinga's *Waning of the Middle Ages*) which have reconstructed the social and religious situation of the Netherlands and of the town of 's-Hertogenbosch in particular.

Certain paintings can be associated with the early works just mentioned because they are animated by a similar spirit; among these are *Ship of Fools* (No. 14) in the Louvre and the Vienna *Ascent to Calvary* (No. 15). Linking the early works with the subsequent period, beginning in about 1490, are paintings such as the two fragments of the *Last Judgement* in New York (No: 16), the *Allegory of Gluttony and Lust*, in New Haven (No. 17) and the *Death of the Miser* in Washington (No. 19).

The second main period, from 1490 to 1500, sees a fairly clear development in the spirit of his compositions which now became wider in scope. *The Hay Wain Triptych* (No. 21) is generally regarded as the first of this group of pictures, at any rate of those which survive. Two versions of the painting are known, one in the Prado and the other in the monastery of the Escorial. The Triptych amplifies a theme already used by Bosch in his early works: that of the short-sighted foolishness of men who abandon themselves to all manner of sin without considering that their fate is part of a divine plan, begun on the day of Creation and destined to end at the Last Judgement.

The 'hay wain' subject, illustrated in the central panel (No. 21C) is taken from a Flemish proverb ('The world is a waggon of hay, everyone grabs what he can'). This fact has been deduced on the basis of an engraving by Bartolomeo de Momper made from the painting in 1559. However, the composition is more than a mere anecdotal representation such as those in the early works. The various episodes, each one illustrating a proverb, are

all part of one continuous composition set in the unitary space of an open landscape. They are to a greater or lesser extent linked in an almost cosmic vision which is paralleled by the actual format of the Triptych, which Bosch was later to use many times and which in this case had become a kind of lay altarpiece. The central scene is either connected with everyday life or else represents stories from the Bible or from the lives of the saints. It is placed between two lateral sections which illustrate the work's message *sub specie aeternitatis*, while the general concept is taken up again in the picture formed by the two closed wings. In the case of *The Hay Wain*, the picture on the closed wings depicts the allegory of the Wayfarer through life (No. 21A). The figure of the vagrant, which may have been based on that of the Fool, 22nd Major Arcanum in the Tarot cards, symbolizes man making his way through all the snares and violence he encounters in his life.

The Garden of Earthly Delights Triptych (No. 28) represents a further step forward. This work is normally dated to the end of the first decade of the sixteenth century but it seems more likely to have been painted at the end of the previous century. It differs considerably from *The Hay Wain* in its trend towards an ever greater universality and increasingly sophisticated abstraction. However, compared with works which came after it, there are marked links with the early phase, regarding both style and composition. One of these similarities is the use of very small-scale figures, who throng the astonishing 'garden' which, in itself, recalls the *hortus conclusus* of medieval tradition rather than the vast spaces we find in Bosch's late works. Another aspect is the lack of spatial or tonal fusion between landscape and figures; the two seem to have been planned and executed independently of one another.

On the other hand, compared with the early works or even with *The Hay Wain Triptych*, his powers of expression seem here to have reached dizzy heights. He uses unprecedented stylizations and incredible, ambiguous images to express the themes of the Creation, Sin and Hell. Here, too, the central panel deals with sinning humanity. The whole Triptych is inspired by a passage

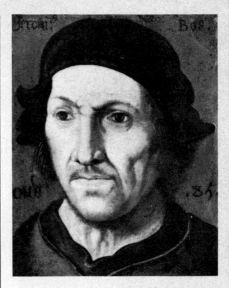

Alleged portrait of Bosch, dated 1585, by an unknown Flemish painter. Amherst, Massachusetts, Amherst College

from the Second Letter of St Peter (3:5–7: 'For this they willingly are ignorant of, that by the word of God the heavens were of old, and the earth standing out of the water and in the water: Whereby the world that then was, being overflowed with water, perished: But the heavens and the earth, which are now, by the same word are kept in store, reserved unto fire against the day of judgement and perdition of ungodly men.')

The central panel depicts humanity before the Flood, giving itself over to sin, as a parallel of contemporary humanity 'before the fire'. The left-hand wing (No. 28B) shows the creation of the world through the word of God, that is, Christ. The right-hand wing (No. 28D) shows the second destruction of the world through fire. The picture on the back of the wings (No. 28A) alludes ambiguously to the third day of the Creation (Genesis 1:9–10: the emergence of the earth from the waters) and to the world after the Flood, as a reminder of the early history of the world, whose first creation and destruction mirrors the second and equally terrible fate to come, the first signs of which are already

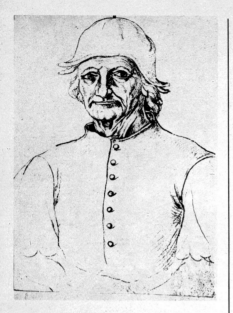

Portrait of Bosch preserved in the codex of the Arras Library known as the 'Recueil d'Arras' (folio 275)

visible. The representation of a deserted earth has no precedent in European painting and it also constitutes the first known example of 'pure' landscape.

The incredible, grotesque images of the pictures on the inside of the Triptych, particularly the right-hand panel (No. 28B) and the central panel (No. 28C), have been deciphered, with much difficulty. Their sources are those which Bosch had already used or was to use in later works: the Bible, *The Golden Legend, The Vision of Tondalus, The Book of Dreams*, the medieval Bestiaries and the images and concepts of popular culture. However, there is an enormous difference in the way these sources are used, compared with the earlier works. The difference lies not only in the perfect orchestration of the individual episodes, which are no longer noticeable as such, but above all in the very modern ambiguity with which sin is represented. Sin is perceived here only as a poetic element, in that the morbid fascination of the absurd images swarming before our eyes seems to belong to a perverse dream. These lucid nightmares,

however, are really part of the authentic tradition of Flemish painting. They are the lay counterpart of religious literature which tended to translate abstract concepts into concrete images, an approach which Panofsky summed up so well with the phrase '*spiritualia sub specie corporalium*'. It has been said that the same love with which Jan van Eyck describes reality can be seen in the passionate resoluteness with which Bosch approaches each single phenomenon, and removes it from its impersonal existence as a mere symbol. In this huge gap between the absolute indifference of the represented object and its real meaning lies Bosch's poetic power in this work which has the stature of a key work, bringing an epoch to a close.

These two triptychs – *The Hay Wain* and *The Garden of Delights* – belong to either end of the last decade of the fifteenth century. Somewhere between them come the fragments of *The Flood Triptych* of Rotterdam (No. 24). Its subject recalls *The Earthly Delights*, while the four *tondi* painted on the back of the wings (Nos. 24 BCEF) seem to be closer to his earliest phase. Similarly the Philadelphia *Ecce Homo* (No. 25) seems to belong to a date no later than the end of the century, particularly because of the small scale of its figures.

The Venetian paintings announce the opening of the new century and an important turning point in Bosch's artistic career. These works are Venetian not only because of their present location but also because they were probably painted in Venice. The *St Julia* altarpiece (No. 30) (it seems correct to return to this title) shows a new handling of space which gives the figures a dominant position within the picture, very different from that of the small figures in the previous works. Moreover, the four panels on eschatological themes (Nos. 31 ABCD), themes which were certainly not new to Bosch, reveal for the first time an unprecedented depth of emotion. None of the artist's earlier work has anything like the relationship discernible in this painting between figures and landscape which are now blended with a new feeling for colour. There are other, more precise indications of a probable visit to Italy, and specifically to Venice, to be found in practically all his subsequent works, the chronology of which is

difficult to determine.

The new feeling for space and landscape gave rise to the series of ascetic pictures, beginning with the Venetian altarpiece of the *Hermit Saints* (No. 32) and including also the *St John on Patmos*, Berlin (No. 33), the Madrid *St John the Baptist in the Wilderness* (No. 34), which seem to be the paintings most closely tied to the preceding phase, and above all the Rotterdam *St Christopher* (No. 36) and the Ghent *St Jerome in Prayer* (No. 39). The size of the figures in relation to the landscape is now much larger and we find in these paintings the first real signs of true landscape painting.

That Bosch stayed in Italy between 1500 and 1503 is also suggested by another aspect of Bosch's work of the final decade: in paintings like the Escorial *Christ crowned with Thorns* (No. 58), the Princeton *Christ before Pilate* (No. 69), the Ghent *Christ bearing the Cross* (No. 70) and the San Diego *Kiss of Judas* (No. 71; copy of a lost original), there is something completely new in the use of the 'half-figure', the origin of which is to be found in Venetian painting, and in particular in Mantegna and Giovanni Bellini. The Ghent *Christ bearing the Cross* (considered to be a replica by the artist's own hand of a lost original dating from the first years of the sixteenth century) shows the influence of Leonardo's studies of grotesque heads. This painting was itself to influence Dürer in his *Christ among the Doctors* in the Thyssen Collection at Lugano (1506). The dating of this series of paintings is usually put much later, towards the end of the artist's career, but a much more flexible approach to their dating is needed. The series was motivated by certain religious sentiments which Bosch had held for some time but which until then he had expressed only by translating into images various doctrinal themes.

With the adoption of this half-length format, which allowed him to represent his subjects almost life-size, even in the relatively small paintings executed for private commissions, Bosch succeeds in arousing in the spectator an emotional participation similar to that associated with the *Devotio moderna*, so widespread in Holland. In these paintings Bosch shows he has reached a far higher level of maturity, compared with another Dutch painter, the anonymous Master of the *Virgo inter Virgines*, regarded as the most important interpreter of the tenets of *Devotio moderna*. That he had this movement in mind when he adopted the half-length figure format is confirmed by another painting which also uses the half-figure but develops it in a way which is not of Venetian origin but Flemish: in the London *Christ crowned with Thorns* (No. 57) Bosch takes an idea from Roger van der Weyden but uses it as a means of illustrating the sacred subject with an unprecedented immediacy, achieved through the figure's dominant presence in the picture, which is free of all other dispersive detail.

These considerations help to show the creative role played by Bosch within the context of this religious movement and also place him beyond doubt among the small group of European artists who were responsible for the most daring experiments in those crucial years. But there is another field in which Bosch was in the vanguard, and perhaps to an even greater degree, and that is in his painting of landscapes in the 'ascetic' pictures and also in the subsequent great triptychs. Two in particular are good examples of the new approach to landscape, even though their compositions do not seem to be compatible with any innovations. The Lisbon *Temptation Triptych* (No. 43) depicts the various temptations of St Anthony in a continuous picture on three panels. The scenery which contains them is less distant than in earlier works and the figures, less crowded, become an integral part of it. The next great triptych, the Vienna *Last Judgement* (No. 50), is difficult to date. The obviously archaic compositional scheme is accompanied by a much newer chromatic quality (which suggests that the work might be a replica by the artist's own hand of an earlier painting, now lost), while the Madrid *Epiphany Triptych* (No. 62) marks the peak of Bosch's landscape painting, which was to give rise to one trend developed by Patinier and another, more domestic and 'bourgeois', followed by Brueghel.

Another of Bosch's late works, the Rotterdam *Prodigal Son* (No. 61), is to be seen in the same light. In it he returns, after many years, to the narrative themes used in his earliest works. However, even at the level of

story-telling, it is clear that Bosch has now achieved a kind of epic quality which dispenses with all gratuitous description. This achievement opened the way to Brueghel's best works and also to a major strand of painting which was to lead to the great seventeenth-century movement of Dutch realism.

There are, therefore, a number of new hypotheses to be made regarding Bosch's activity between 1504 and 1516, and several possible lines of research. Preliminary signs of the way he was to develop during this period were already to be found in his earliest works and are closely connected with his desire to play an active role in the lively cultural and religious debate which was taking place in the Netherlands between the fifteenth and sixteenth centuries. He is certainly to be regarded as one of the most original and representative voices in that debate. As in the case of many other great European artists of that time, his real legacy was only partially understood and followed. His fantastic creations did achieve fame, but this eventually led to mere exercises in the grotesque. The most enduring aspect of his art is found, as I have tried to point out, in the artist's determination to fill an intellectual role, in his perception of reality strictly in the context of the various phenomena of which it is composed, and in his search for new ways of expressing religious subjects in order to satisfy the rapidly growing need of the individual to understand and share these themes.

I have tried to explain some of the new impulses in Bosch's development in the years after 1500 by postulating an Italian journey, but this is certainly no more than a partial explanation, and further theories and discoveries are needed in order to reconstruct the various stages of his career, of which we still have only a sketchy outline.

* * *

The catalogue of paintings which follows includes works which are unanimously regarded as being by Bosch's own hand and others known only through copies (these are indicated as they occur). It also includes paintings of doubtful authenticity but of considerable interest because of their connection with known or lost works by the artist (Nos. 16, 29, 40, 41, 42, 44, 46, 49, 50, 51, 54, 56, 60, 63, 64, 65, 66, 71, 73).

The Cure for Madness (No. 1).
The text, in Gothic lettering, means literally: 'Master, cut the stone [of madness] out, my name is Lubbert Das', the popular name for a foolish, gullible peasant.

Catalogue of the Paintings

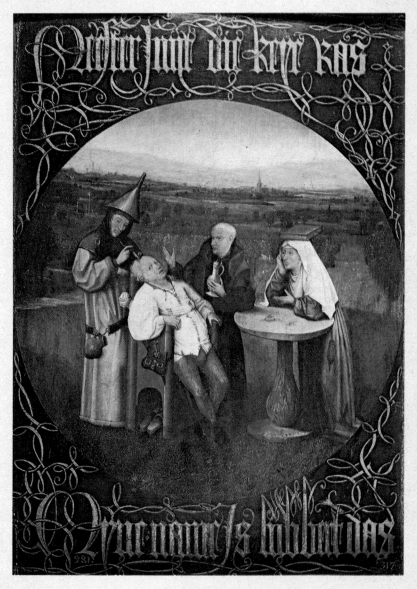

1475–1485

1 The Cure for Madness
Oil on panel/48 × 35/
Madrid, Prado
**1a Copy of No. 1 with
variations**
Amsterdam, Rijksmuseum

2 The Seven Deadly Sins
Oil on panel/120 × 150/
Madrid, Prado

3 The Marriage at Cana
Oil on panel/93 × 72/
Rotterdam, Museum
Boymans-van Beuningen
**3a Copy of No. 3, made before
the dogs were added**
Location unknown

4 Christ with the Adulteress
Oil on panel/82 × 54.8/
Philadelphia, Museum of Art
(Johnson Collection)
Copy of a lost original

5 Two Heads of Priests
Oil on panel/14.5 × 12/
Rotterdam, Museum
Boymans-van Beuningen

1

1a

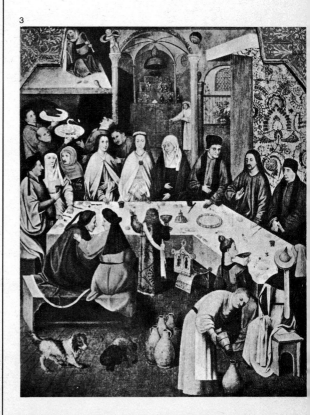

3

*All measurements are in
centimetres.*

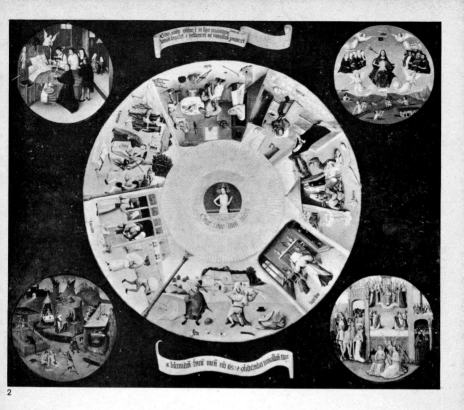

2

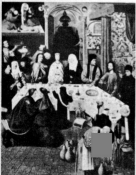

3a

4a

5

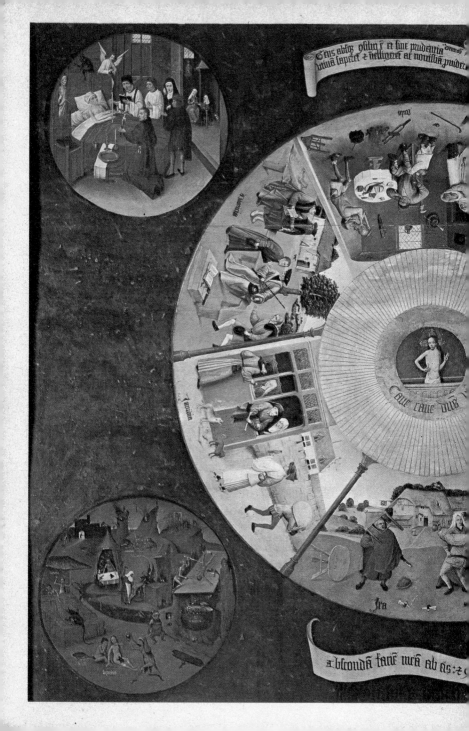

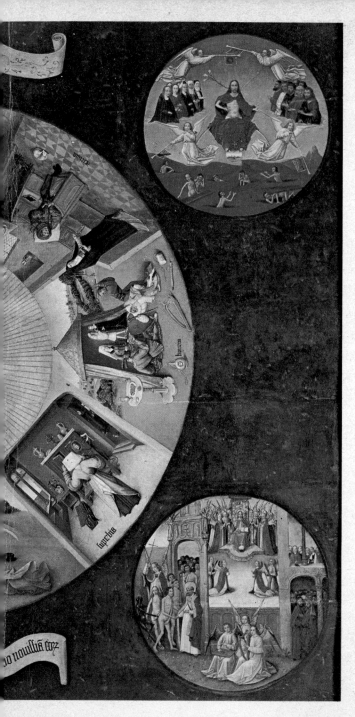

The Seven Deadly Sins (No. 2).
The text in the centre, below the figure of Christ ('Cave, cave, Dominus videt'*) refers to God's omniscience which men's sinful actions cannot evade.*

15

6 The Conjuror
Oil on panel/53 × 65/
St Germain-en-Laye, Musée
Municipal
Copy of a lost original
6a Copy of No. 6 with variations
Philadelphia, Museum of Art
(Wilstach Collection)
6b Copy of No. 6 with variations

7a Concert in an Egg
Oil on canvas/107 × 125/
Lille, Musée Wicar
7b idem
Paris, R. Barny d'Avricourt
Collection
Copies of a lost original
documented by a drawing
preserved in Berlin,
Kupferstichkabinett (7c).

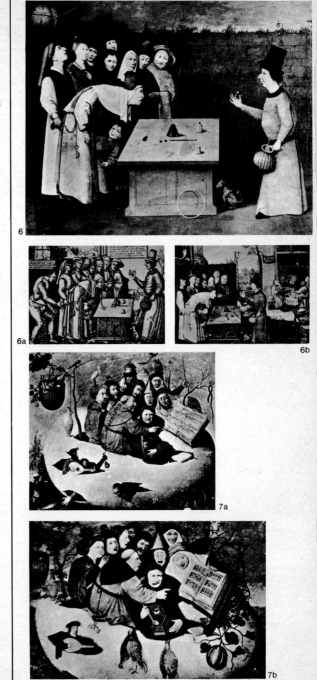

6

6a

6b

7a

7b

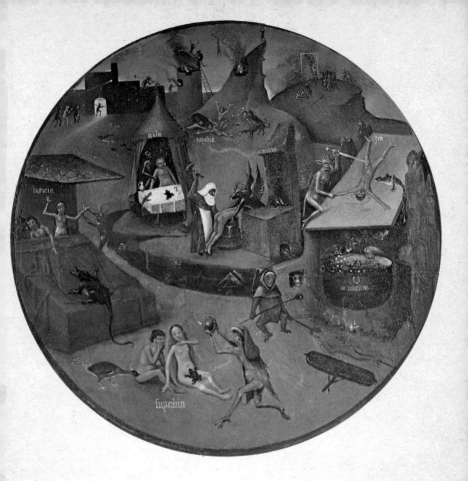

The Seven Deadly Sins (No. 2; detail of Hell).
At the four corners of the painting are four tondi *representing the 'Four Last Things' (death, last judgement, hell, paradise), to indicate the inevitable outcome of all things human.*

17

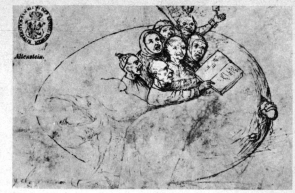

7c

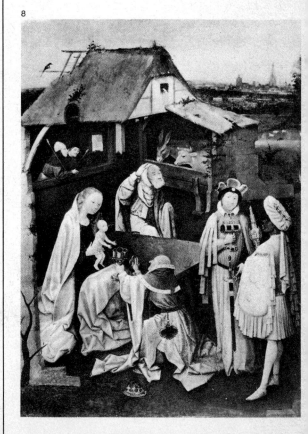

8

8 The Adoration of the Magi
Oil on panel/74 × 54/
Philadelphia, Museum of Art
(Johnson Collection)

The Seven Deadly Sins (No. 2; detail of Gluttony).
In illustrating the seven deadly sins the artist uses scenes from everyday life.

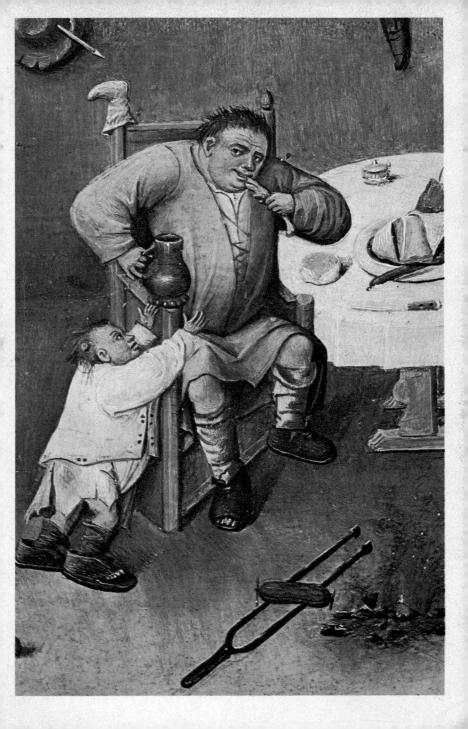

1475–1485

9 Crucifixion
Oil on panel/70.5 × 59/
Brussels, Musée des Beaux-
Arts

10 Ecce Homo
Oil on panel/75 × 61/
Frankfurt, Städelsches
Kunstinstitut

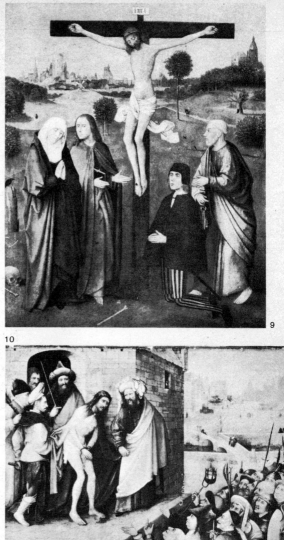

9

10

*The Seven Deadly Sins (No. 2;
detail of Pride).*
*The sin of pride is represented
by a woman trying out a
headdress in front of a mirror
held up by the Devil.*

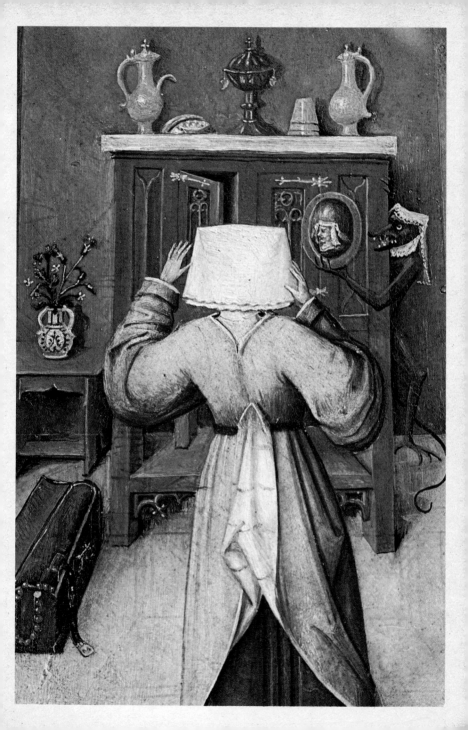

1475–1485

11A–C Ecce Homo
Oil on panel/73 × 58/
Boston, Museum of Fine Arts
Copy of No. 10 with
variations and additions

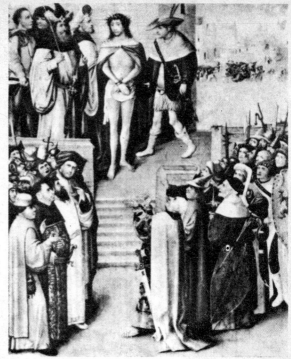

11A

The Conjuror (No. 6; detail).
This is another work
illustrating the theme of man's
gullibility (the conjuror is
making one of the spectators
appear to spit toads out of his
mouth, while an accomplice is
robbing him from behind).

11B 11C

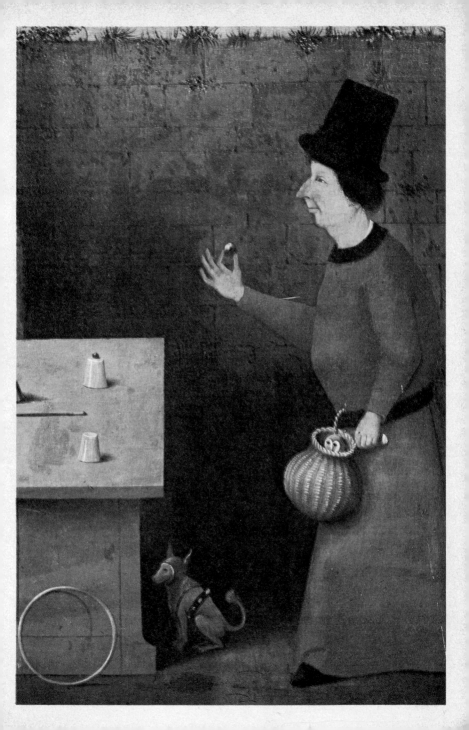

1485–1490

12a Christ among the Doctors
Oil on panel/74.2 × 58/
Paris, Louvre
12b idem
Florence, Weintzheimer
Collection
Copies of an original painting
now lost

**13a Abigail and David; 13b
Solomon and Bathsheba**
Switzerland, Private
Collection
Probably copies of two lost,
documented paintings

14 Ship of Fools
Oil on panel/57.8 × 32.5/
Paris, Louvre

12a

12b

13a

13b

The Ascent to Calvary
(No. 15). (pp. 26–7)
*This is the surviving section of
a lost triptych dealing with the
Passion. The return to the so-
called 'soft style' is
reminiscent of Bosch's early
works.*

24

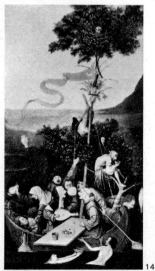

14

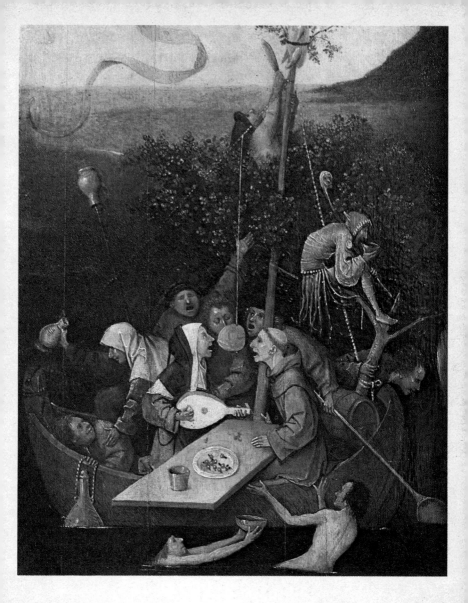

Ship of Fools (*No. 14; detail*).
*This may be part of a lost
series dealing with the various
sins; the painting is inspired
by a theme widespread in
Flemish literature and which
was the basis of the satirical
poem by Brant
(*NARRENSCHIFF*).*

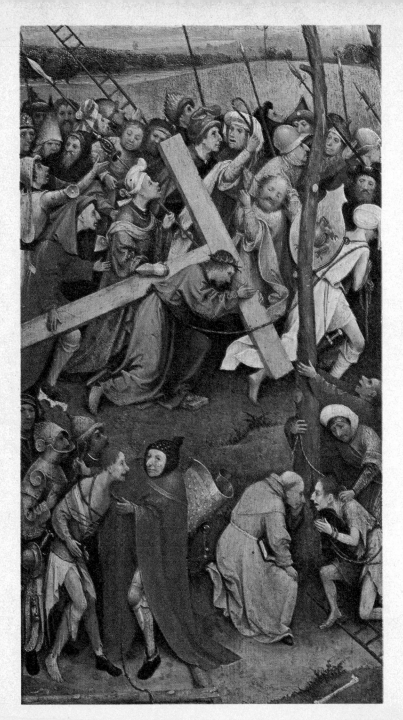

1485–1490

15A The Ascent to Calvary
15B Child playing
Oil on panel/57.2 × 32/
Vienna, Kunsthistorisches
Museum

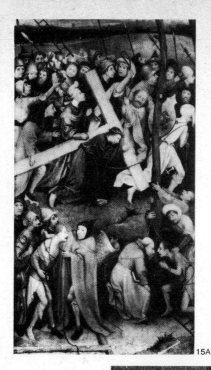

15A

15B

**The Hay Wain Triptych
(closed) (No. 21A).**
*The picture formed by the
back of the triptych's wings
when closed is an allegory of
human life, whose path is
littered with dangers and
violence.*

28

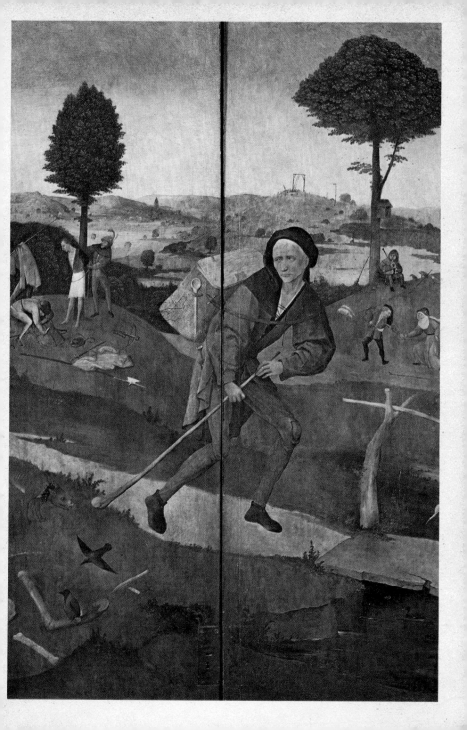

1485–1490

FRAGMENTS OF A LAST JUDGEMENT TRIPTYCH
16A Death of the Just Man
Oil on panel/34.5 × 21/
New York, Wildenstein
Gallery
16B Death of the Reprobate
Oil on panel/33.4 × 19.6/
New York, Wildenstein
Gallery

**17 Allegory of Gluttony and
Lust**
Oil on panel/31 × 35/
New Haven, Yale University
Art Gallery, Rabinowitz
Collection

18 Head of a Woman
Oil on panel/13 × 5/
Rotterdam, Museum
Boymans-van Beuningen

19 Death of the Miser
Oil on panel/92.6 × 30.8/
Washington, National
Gallery of Art (Kress
Collection)

20 The Ascent to Calvary
Tempera on canvas/
46.5 × 36.5/
Formerly in London, Arnot
Gallery
Probably a copy of a lost
original

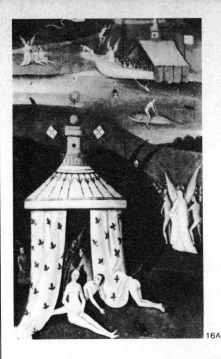

16A

17

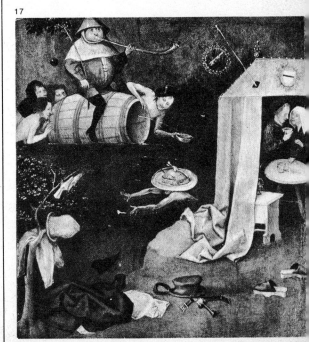

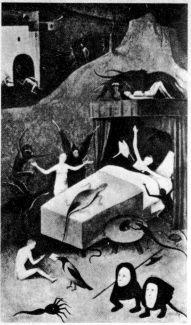

18

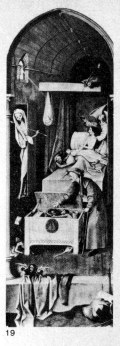

6B

19

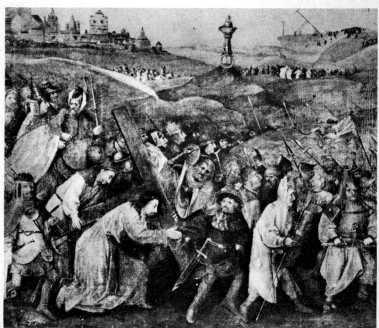

20a

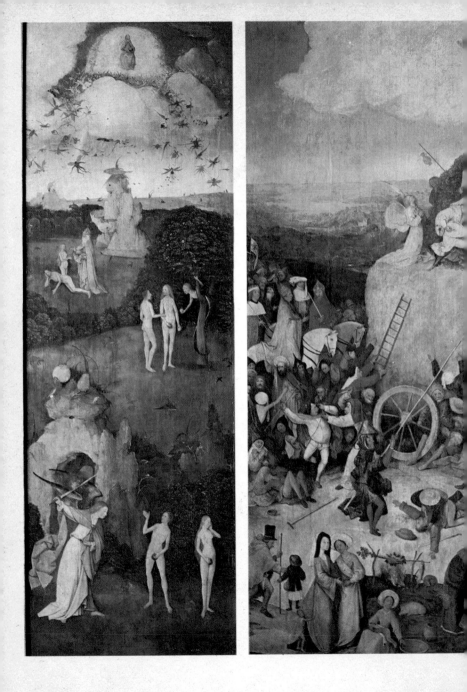

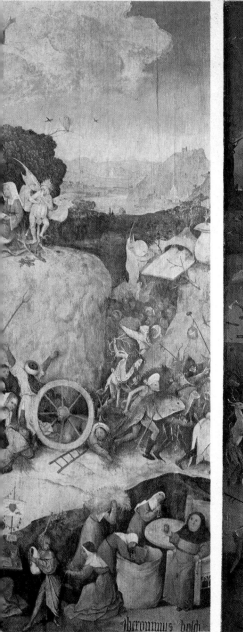
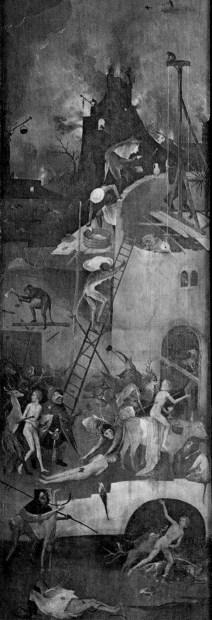

The Hay Wain Triptych (**open**) (*No. 21BCD*).
THE HAY WAIN *is the earliest of the great triptychs to come down to us in its entirety. Already we have a foretaste of the extraordinary inventions of the artist's later period, while his moralistic intention is still overtly expressed.*

1490–1500

**THE HAY WAIN
TRIPTYCH**
Madrid, Prado
21A The Path of Life
Oil on panel/135 × 90/
21B The Original Sin
Oil on panel/135 × 45/
21C The Hay Wain
Oil on panel/135 × 100/
21D The Towers of Hell

22 The Hay Wain Triptych
Oil on panel/140 × 232
(open)/
Escorial, Monastery of San
Lorenzo
Workshop replica of No. 21

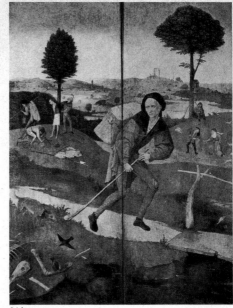

21A

22A

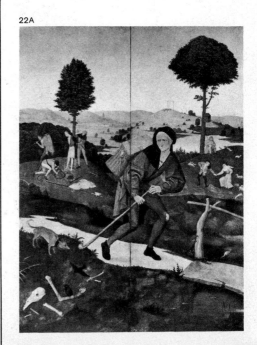

34

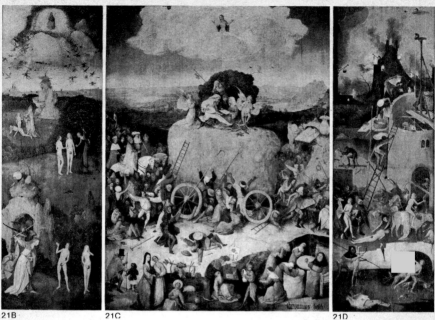

21B 21C 21D

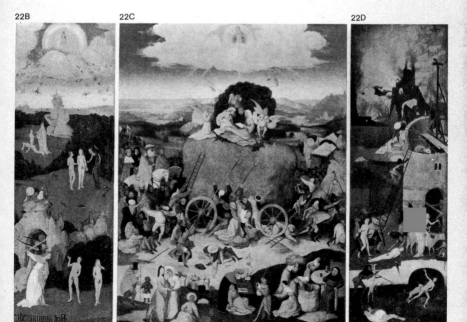

22B 22C 22D

23 The Battle between Carnival and Lent
Oil on panel/57 × 116/
The Hague, Gallery Cramer
Copy of a lost original

THE FLOOD TRIPTYCH
Rotterdam, Museum
Boymans-van Beuningen
24A The Evil World
**24BC The Devil in the House
and the Devil in the Country**
Oil on panel/69 × 36/
**24D The World after the
Flood**
**24EF The Damned and the
Saved**
Oil on panel/69.5 × 38/

23a

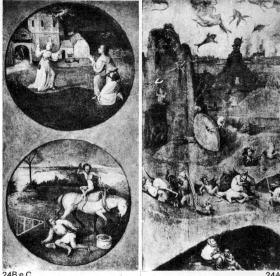

24B e C

24A

**The Hay Wain Triptych
(No. 21B; detail).**
*The Fall of the Rebel Angels,
the Creation of Eve, the Sin
and the Expulsion from the
Garden of Eden, are the
themes of this section; they
illustrate the prehistory of the
human race and the origins of
its fallibility.*

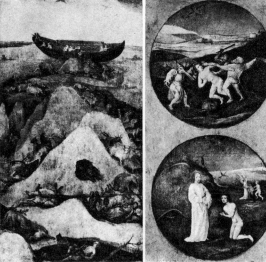

24D

24E e F

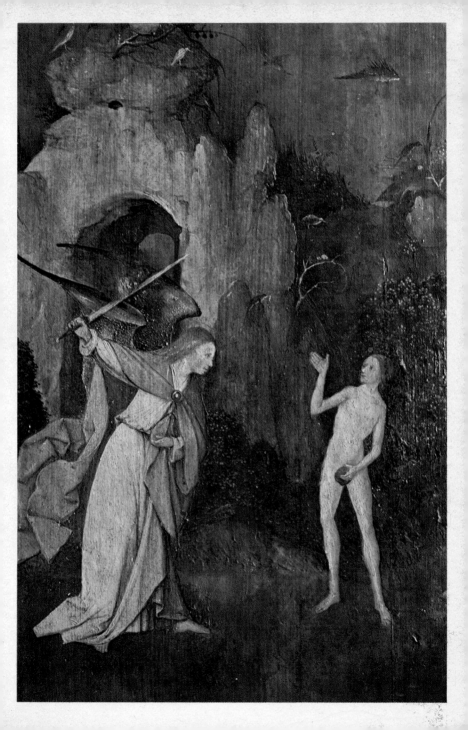

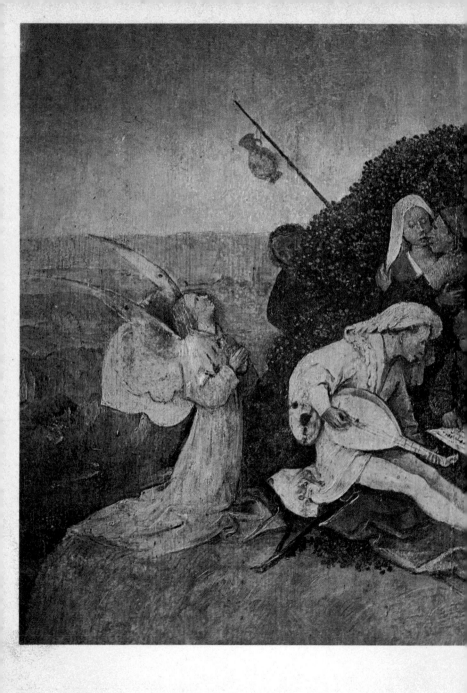

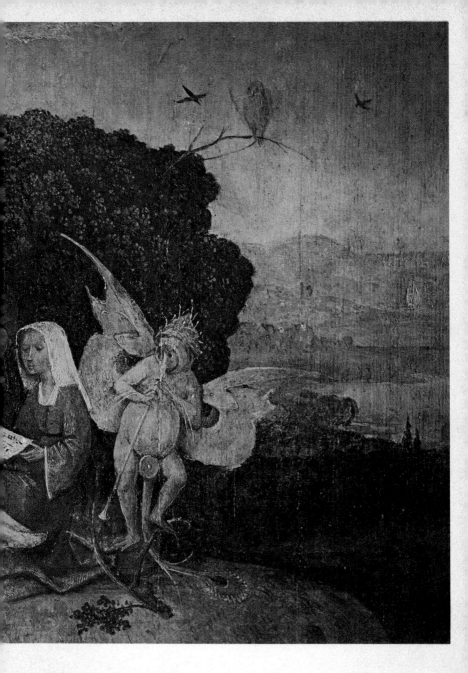

The Hay Wain Triptych (No. 21C: detail).
On Top of the hay wain is a group of sinners, between a devil and an angel; the latter is looking up towards Christ, man's only hope of salvation.

1490–1500

25 Ecce Homo
Oil on panel/50 × 52/
Philadelphia, Museum of Art
(Johnson Collection)

26 Ecce Homo
Oil on panel/62.5 × 53/
Switzerland, Private
Collection

**27A St James and the
Sorcerer Hermogenes
27B The Temptation of St
Anthony**
Oil on panel/60 × 40/
Valenciennes, Musée des
Beaux-Arts

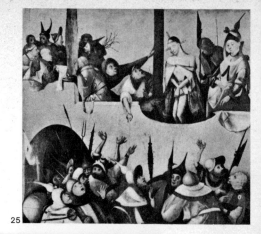

25

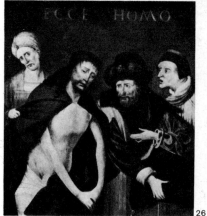

26

27A

27B

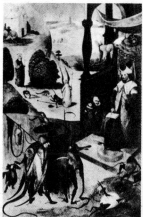
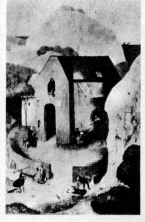

**The Hay Wain Triptych
(No. 21D; detail).**
*Here we see the conclusion of
the triptych's allegory: Hell.
This is the first of Bosch's
famous subterranean and fiery
visions.*

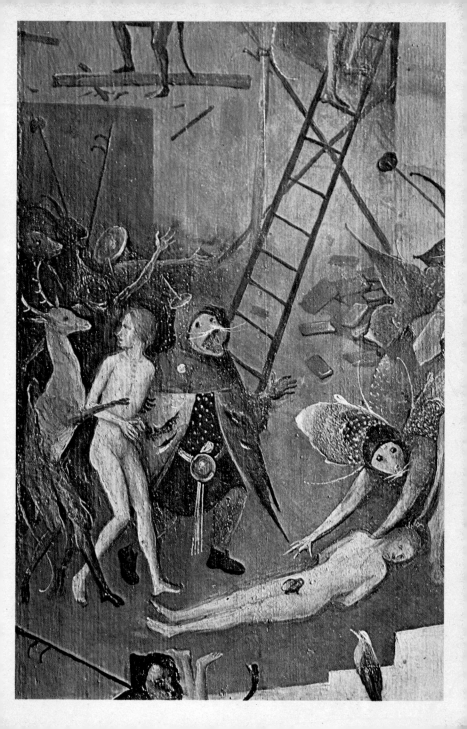

1490–1500

THE GARDEN OF EARTHLY DELIGHTS TRIPTYCH
Madrid, Prado
28A The Creation of the World (or The World after the Flood?)
Oil on panel/220 × 195/
28B Earthly Paradise
Oil on panel/220 × 195/
28C The Garden of Earthly Delights (Man before the Flood)
Oil on panel/220 × 195/
28D Musical Hell
Oil on panel/220 × 97/

29 Earthly Paradise
Oil on panel/27 × 40.6/
Chicago, Art Institute (R. A. Waller Foundation)

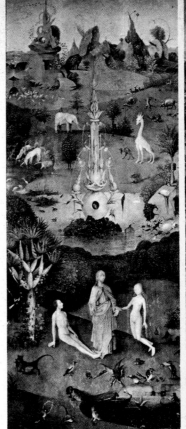

28B

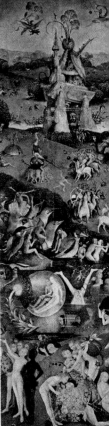

28C

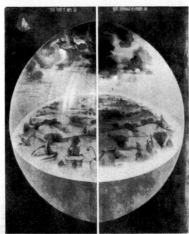

28A

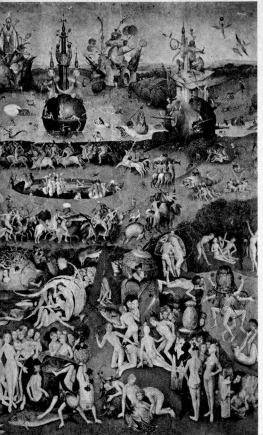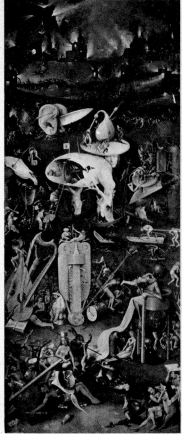

28D

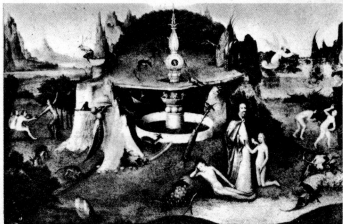

29

1500–1503

ALTARPIECE OF ST JULIA (OR ST LIBERATA?)
Venice, Palazzo Ducale
30A The City in Flames
Oil on panel/104 × 28/
30B The Martyrdom of St Julia (or St Liberata?)
Oil on panel/104 × 63/
30C The Harbour
Oil on panel/104 × 28/

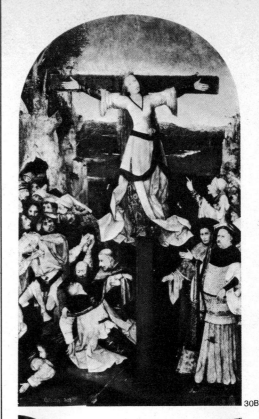

30B

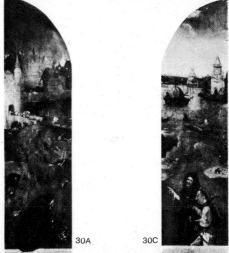

30A 30C

The Hay Wain Triptych (No. 21D; detail).
Against the background of a fiery sky, the devils are engaged in building the infernal city.

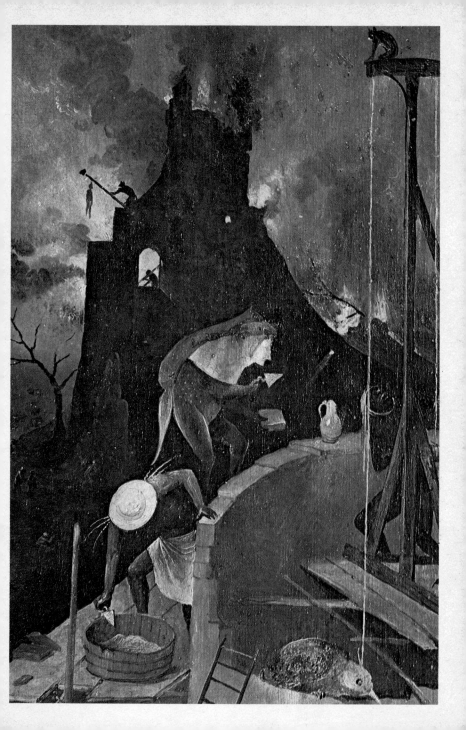

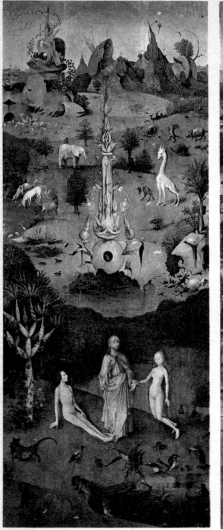
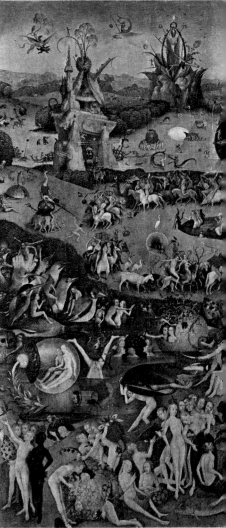

***The Garden of Earthly
Delights Triptych (open)
(No. 28BCD).***
*While the wings clearly depict
Earthly Paradise and Hell, the
central panel, crowded with
fantastic inventions, has given
rise to very many extravagant
interpretations.*

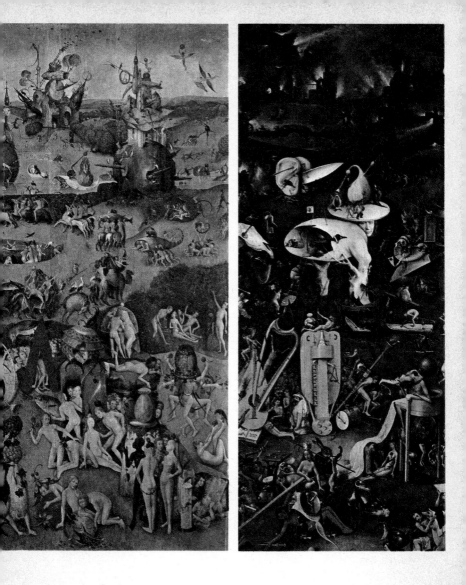

1500–1503

VISIONS OF THE HEREAFTER
Venice, Palazzo Ducale
31A The Fall of the Damned
Oil on panel/87 × 40/
31B Hell
Oil on panel/87 × 40/
31C Earthly Paradise
Oil on panel/87 × 40/
31D The Ascent into the Empyrean
Oil on panel/87 × 40/

31A

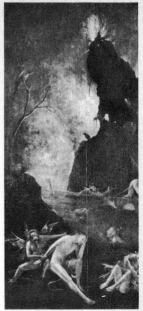

31B

31C

31D

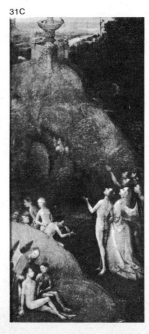

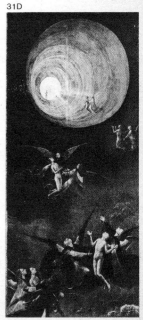

The Garden of Earthly Delights Triptych (No. 28B; detail).
This rare iconography, of Christ creating Eve, refers to the creation of the world through the Word of God.

48

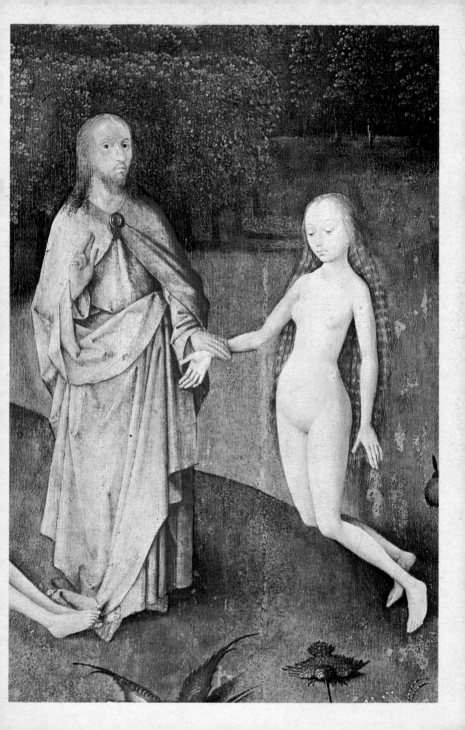

ALTARPIECE OF THE
HERMIT SAINTS
Venice, Palazzo Ducale
32A St Anthony
Oil on panel/86.5 × 29/
32B St Jerome
Oil on panel/86.5 × 50/
32C St Giles
Oil on panel/86.5 × 29/

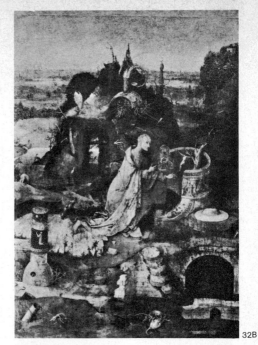

32B

32A

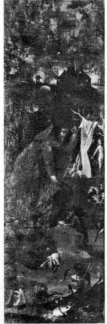

32C

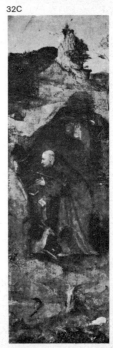

The Garden of Earthly
Delights Triptych (No. 28C;
detail).
The sources for the infinite
number of figures which
throng the triptych have been
traced to the Bible, medieval
Bestiaries and to popular
tradition.

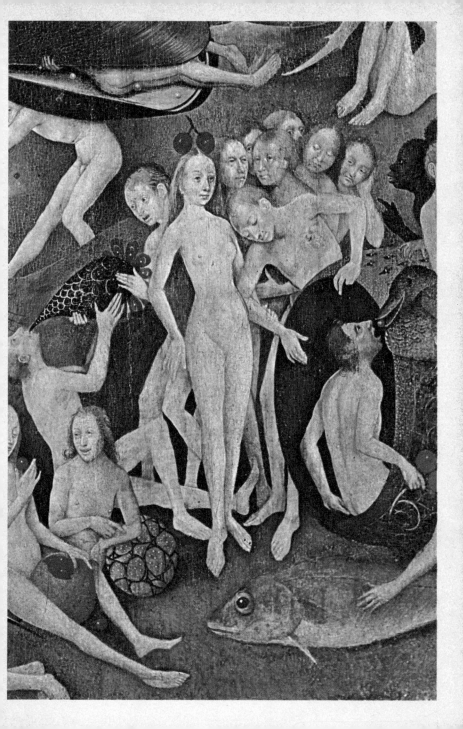

1500–1503

33A St John on Patmos
33B Scenes from the Passion
Oil on panel/63 × 43.3/
Berlin-Dahlem, Staatliche
Museen

34 St John the Baptist in the Wilderness
Oil on panel/48.5 × 40/
Madrid, Museo Lázaro
Galdiano

1504–1510

35 The Last Judgement
A documented work of 1504,
now lost

36 St Christopher
Oil on panel/113 × 71.5/
Rotterdam, Museum
Boymans-van Beuningen

37 The Small St Christopher
Oil on panel/45 × 20/
Madrid, Private Collection

33A

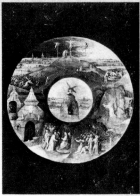

33B

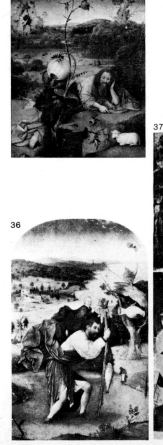

34

37

36

The Garden of Earthly Delights Triptych (No. 28C; detail).
Some of the images in the Garden have never been satisfactorily explained; for example, the two figures emerging from beneath the ground, who have been identified as Adam and Eve.

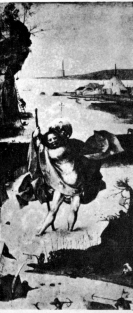

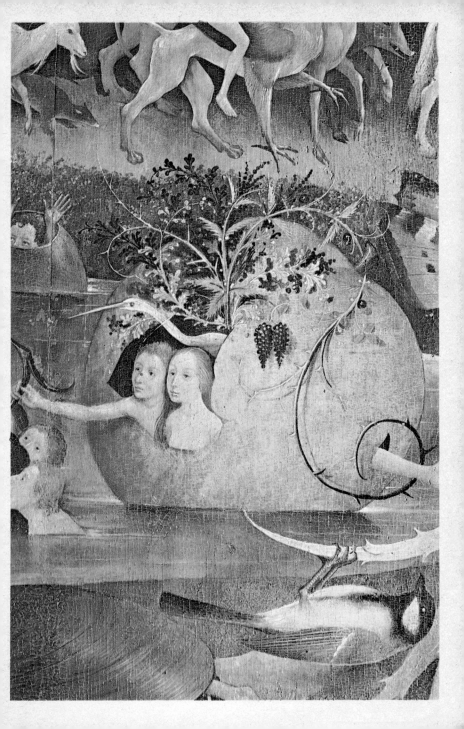

1504–1510

38 St Christopher
Oil on panel/23 × 36/
Winterthur, Reinhart
Collection
Probably a copy of a lost
original

39 St Jerome in Prayer
Oil on panel/77 × 59/
Ghent, Musée des Beaux-Arts

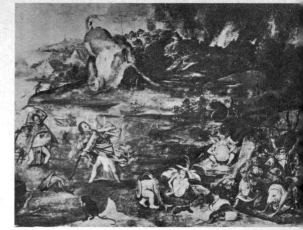

38a

39

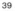

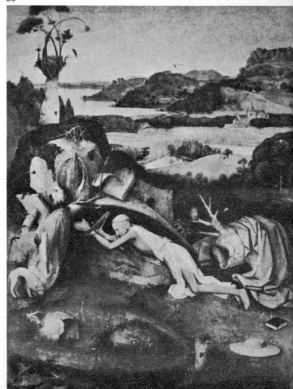

**The Garden of Earthly
Delights Triptych (No. 28C;
detail).**
*The general impression given
by the central section of the
triptych does match the work's
traditional title, whatever its
real significance may be.*

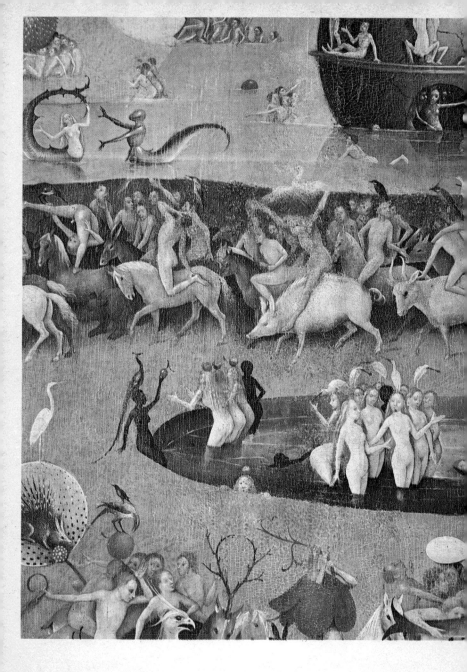

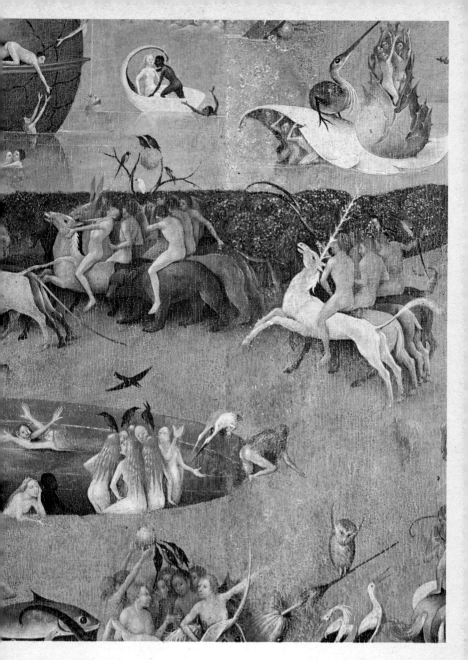

The Garden of Earthly Delights Triptych (No. 28C; detail).
In the centre of the triptych, a procession of men mounted on animals, each of which symbolizes a particular sin, rides round a circular pool.

1504–1510

40

40 The Temptation of St Anthony
Oil on panel/41.25 × 26.25/
New York, Chrysler
Collection

41 The Temptation of St Anthony
Oil on panel/38.4 × 24.3/
Kansas City, Gallery of Art

THE TRIBULATIONS OF JOB TRIPTYCH
Bruges, Musee Groeningen
42A The Temptation of St Anthony
Oil on panel/98.1 × 30.5/
42B The Tribulations of Job
Oil on panel/98.3 × 72.1
42C The Penitence of St Jerome
Oil on panel/98.8 × 30.2/

42B

The Garden of Earthly Delights Triptych (No. 28D; detail).
The Musical Hell panel is dominated by a man-tree figure, which has never been satisfactorily explained.

41

42A 42C

58

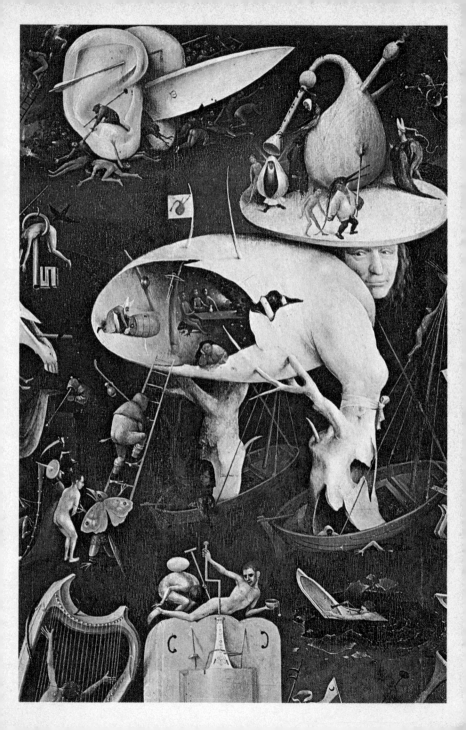

1504–1510

**THE TEMPTATION OF ST
ANTHONY TRIPTYCH**
Lisbon, Museu Nacional de
Arte Antiga
43A The Seizing of Christ
Oil on panel/131.5 × 53/
43B St Veronica
Oil on panel/131.5 × 53/
***43C The Flight and Fall of St
Anthony***
Oil on panel/131.5 × 53/
***43D The Temptation of St
Anthony***
Oil on panel/131.5 × 119/
***43E The Meditation of St
Anthony***
Oil on panel/131.5 × 53/

***44 The Temptation of St
Anthony***
Oil on panel/88 × 72/
Madrid, Prado

45 The Ascent to Calvary
Oil on panel/150 × 94/
Madrid, Royal Palace

43A 43B

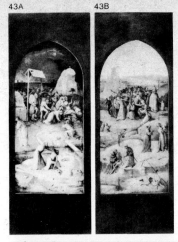

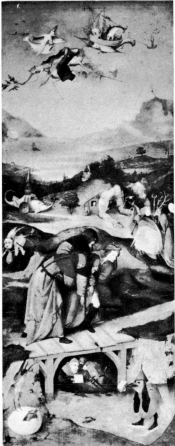

43C 43D

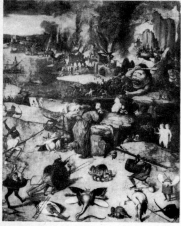

44

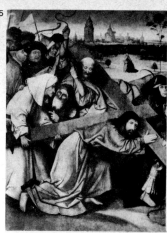

45

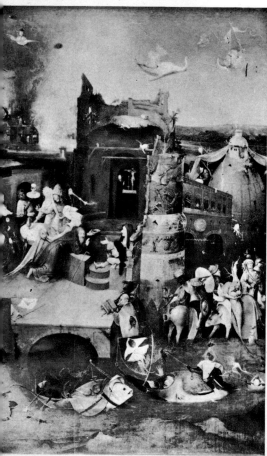

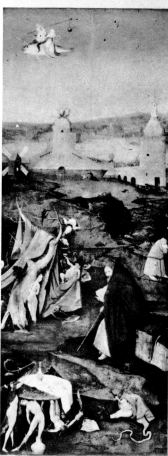

43E

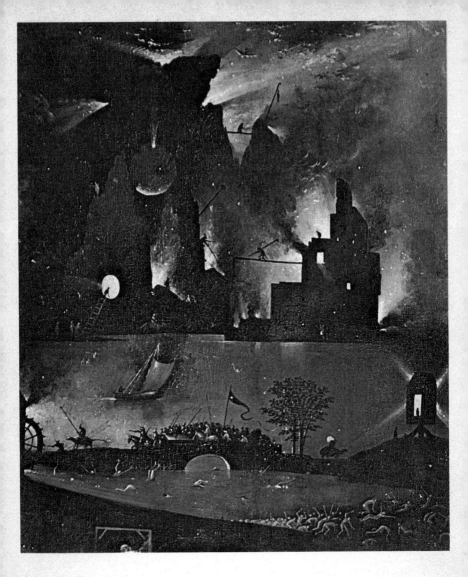

**The Garden of Earthly
Delights Triptych (No. 28D;
detail).**
The extraordinary, fiery
nocturnal landscape which
forms the background in the
Hell section is an allusion to
the end of the world by fire.

**The Garden of Earthly
Delights Triptych (No. 28D;
detail).**
The musical instruments which
torment the damned have been
interpreted as the negative
counterpart of celestial
harmony.

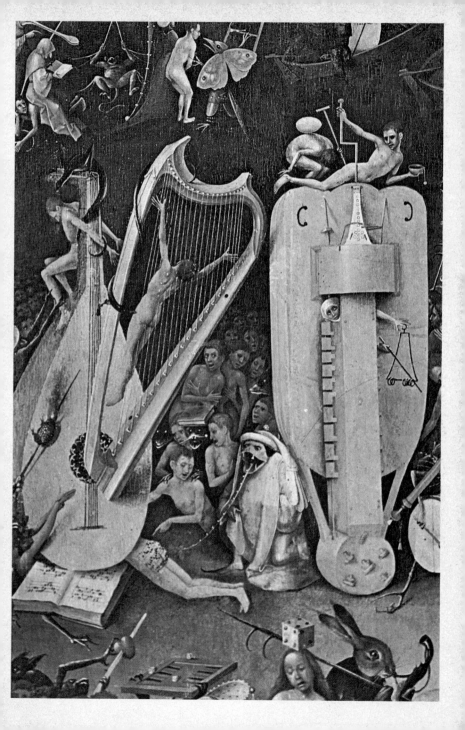

46 The Temptation of St Anthony
Oil on panel/27 × 21/
London, Partridge Ltd

47a The Temptation of St Anthony
Oil on panel/59 × 80/
Amsterdam, Rijksmuseum
47b idem
Oil on panel/70 × 100
Madrid, Prado
Copies of a lost original

48 The Last Judgement
Oil on panel/60 × 114/
Munich, Alte Pinakotek

49 The Temptation of St Anthony
Oil on panel/59 × 51/
's-Hertogenbosch, Frau van Lanschot

46

47a

47b

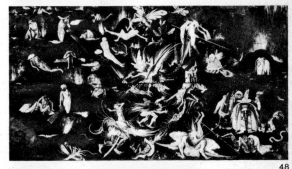

48

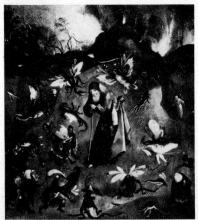

49

*Visions of the Hereafter
(No. 31D; detail).*
In the ASCENT INTO THE
EMPYREAN *the traditional
iconography of the celestial
spheres is transformed by
Bosch into an impressive and
original pictorial invention.*

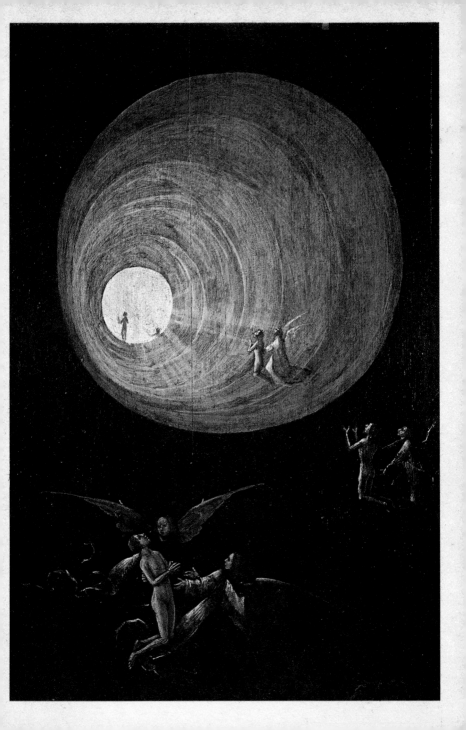

1504–1510

THE LAST JUDGEMENT TRIPTYCH (VIENNA)
Vienna, Akademie der Bildenden Künste
50A St James Major
Oil on panel/167.7 × 60/
50B St Baavo
Oil on panel/167.7 × 60/
50C The Original Sin
Oil on panel/167.7 × 60/
50D The Last Judgement
Oil on panel/167.7 × 127/
50E Hell
Oil on panel/167.7 × 60/

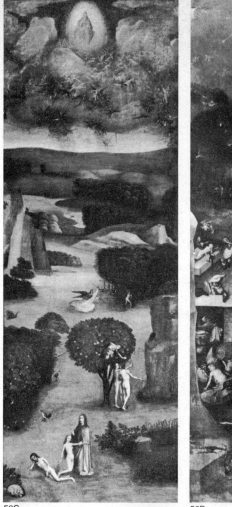

50C

50D

50A

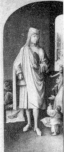

50B

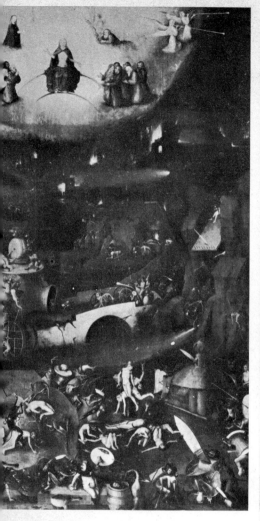

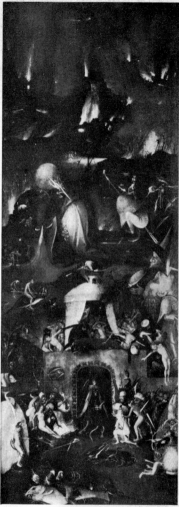

50E

51A 51B

1504–1510

THE LAST JUDGEMENT TRIPTYCH (BRUGES)
Bruges, Musée Groeningen
Probably copied from a lost original
51AB Christ crowned with Thorns
Oil on panel/199 × 57.3
51C The Elect
Oil on panel/99.5 × 28.8/
51D The Last Judgement
Oil on panel/99 × 60.3/
51E The Damned
Oil on panel/99.5 × 28.5/

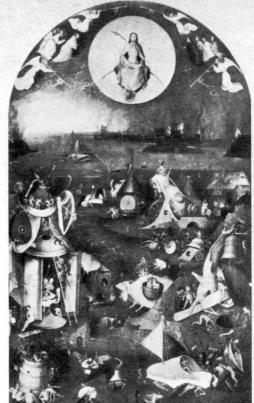

51D

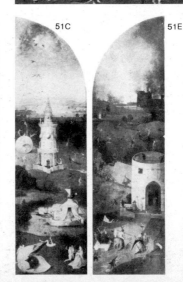

51C

51E

Visions of the Hereafter: Hell (No. 31B; detail).
In the four eschatological paintings in Venice, Hell and Paradise are represented with compositions which are more controlled, and which contain a number of details of a more spiritual quality than can be seen in earlier works.

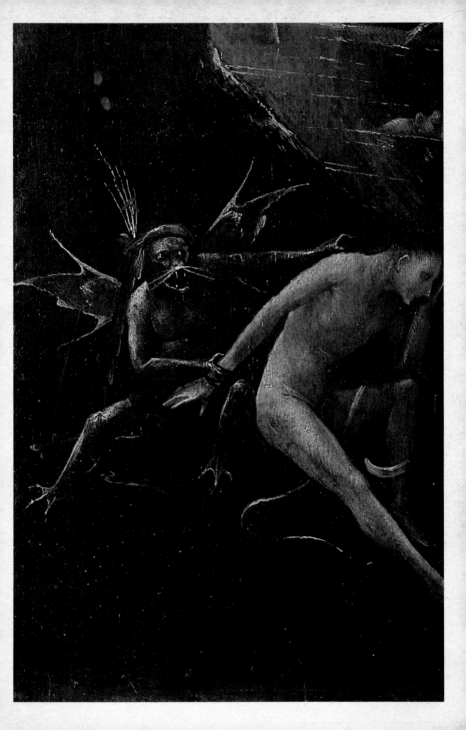

52 The Last Judgement
Oil on panel/83.5 × 93.5/
USA, Private Collection
Probably a copy of a lost
original

**53 Engraving by Allaert de
Hameel from an original
painting**
by Bosch now lost

**54 The Adoration of the Holy
Child**
Oil on panel/66 × 43/
Cologne, Wallraf-Richartz
Museum

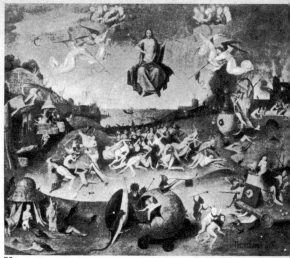

52a

53a

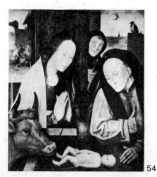

54

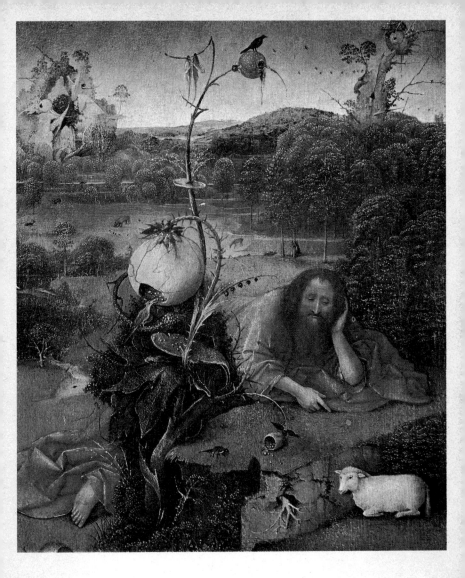

***St John the Baptist in the
Wilderness (No. 34).***
*This is perhaps the earliest of
the 'ascetic' paintings, because
its minute description of
landscape is similar to that of
the* GARDEN OF EARTHLY
DELIGHTS TRIPTYCH.

71

1504–1510

55a Christ crowned with Thorns
Oil on panel/82 × 60/
Berne, Kunstmuseum
55b idem
Oil on panel/85 × 69/
Antwerp, Musée Royal des
Beaux-Arts
Copies of a lost original

56 Head of a Crossbowman
Oil on panel/28 × 20/
Madrid, Prado

57 Christ crowned with Thorns
Oil on panel/73 × 59/
London, National Gallery

1510–1516

58 Christ crowned with Thorns
Oil on panel/165 × 195/
Escorial, Monastery of San
Lorenzo

**59 The Temptation of St
Anthony**
Oil on panel/70 × 51/
Madrid, Prado

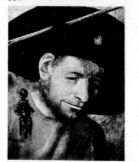
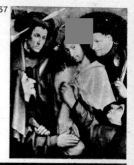

55a 55b

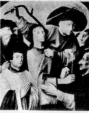

57

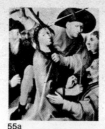

56

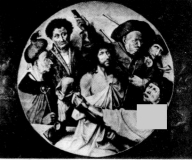

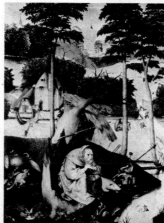

58

**The Temptation Triptych
(No. 43D; detail).**
*This is the third of the great
triptychs. The episodes are
taken from the* Life of St
Anthony *by St Athanasius.*

**The Temptation Triptych
(No. 43D; detail) (pp. 74–5)**
*In the midst of the terrible
witches' sabbath which the
Devil has unleashed against St
Anthony, the saint is drawing
attention to a chapel where
Christ appears, pointing to the
Crucifix, man's only hope of
salvation.*

59

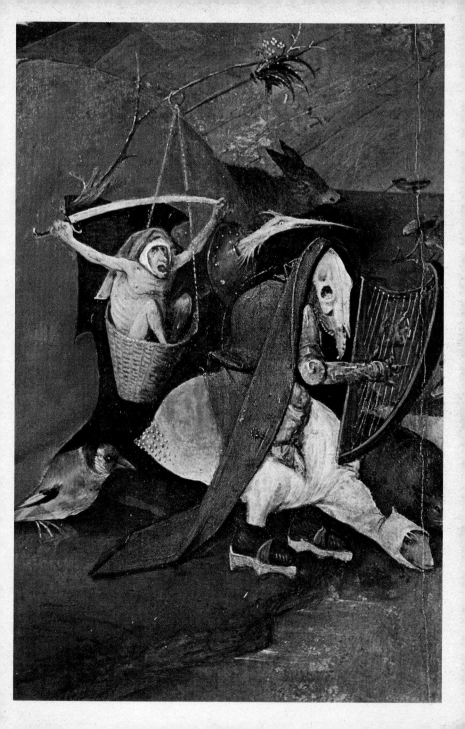

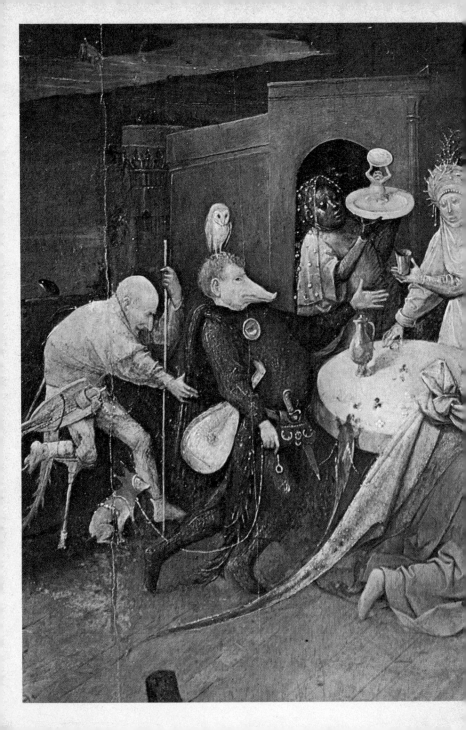

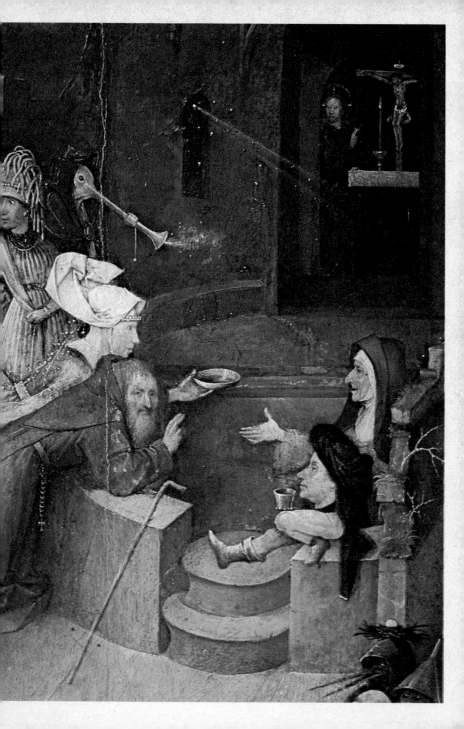

60 The Temptation of St Anthony
Oil on panel/40 × 26.5/
Berlin-Dahlem, Staatliche
Museen

61 The Prodigal Son
Oil on panel/71 × 70.6/
Rotterdam, Museum
Boymans-van Beuningen

60

*The Temptation Triptych
(No. 43D; detail). (pp. 78–9)
The representation of the city
in flames, partly realistic,
partly fantastic, introduces a
genre which was to be widely
used in Flemish painting.*

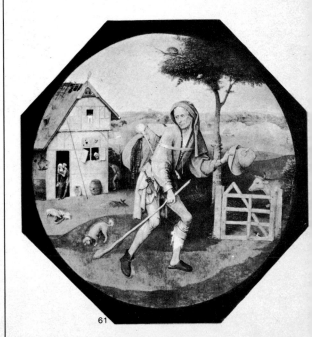

61

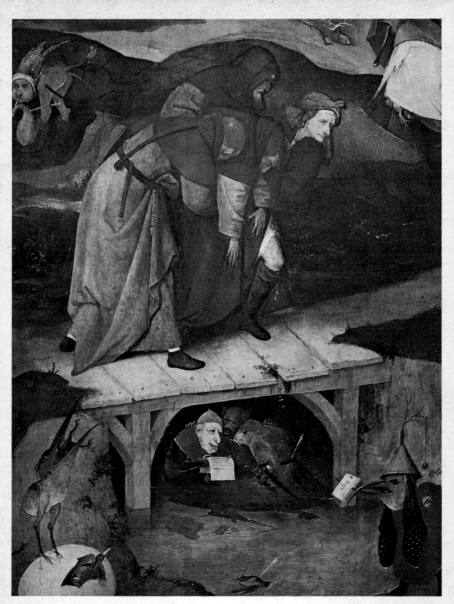

**The Temptation Triptych
(No. 43C; detail).**
*The left-hand panel shows St
Anthony carried in flight by
the devils and gathered up by
his companions after the fall.
The vast landscape of the
background is particularly
fascinating.*

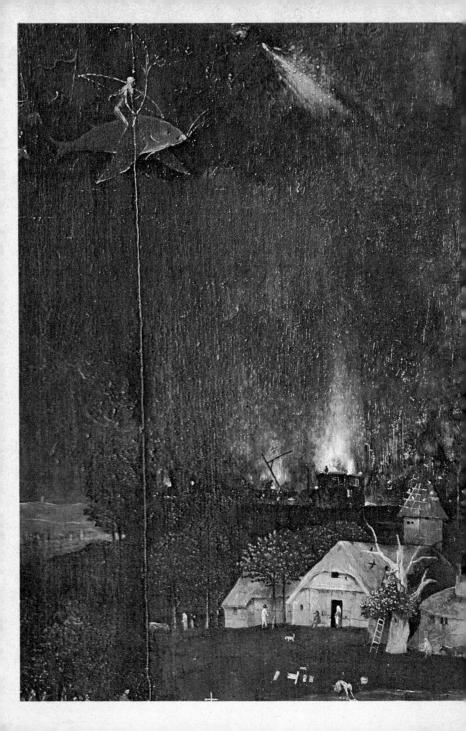

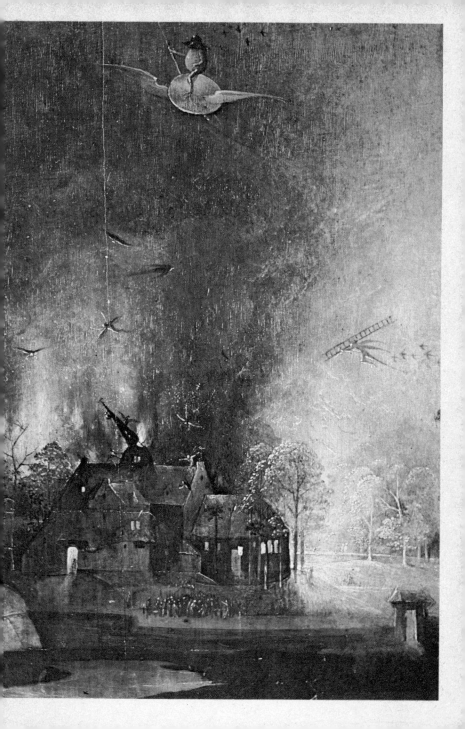

THE EPIPHANY TRIPTYCH (MADRID)
Madrid, Prado
62A The Mass of St Gregory
Oil on panel/138 × 66/
62B St Peter and the Donor
Oil on panel/138 × 33/
62C The Adoration of the Magi
Oil on panel/138 × 72/
62D St Agnes and the Donor
Oil on panel/138 × 33/

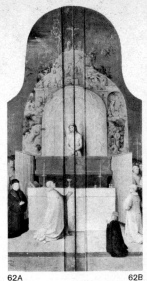

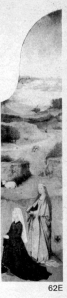

62A 62B 62C 62E

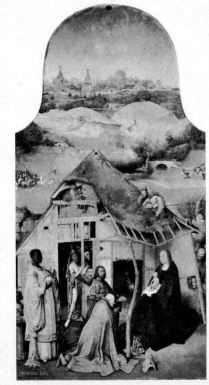

The Last Judgement Triptych, Vienna (No. 50C; detail).
Bosch's repertoire of fantastic images must have achieved such success that replicas (as this triptych probably is) were commissioned from him.

62D

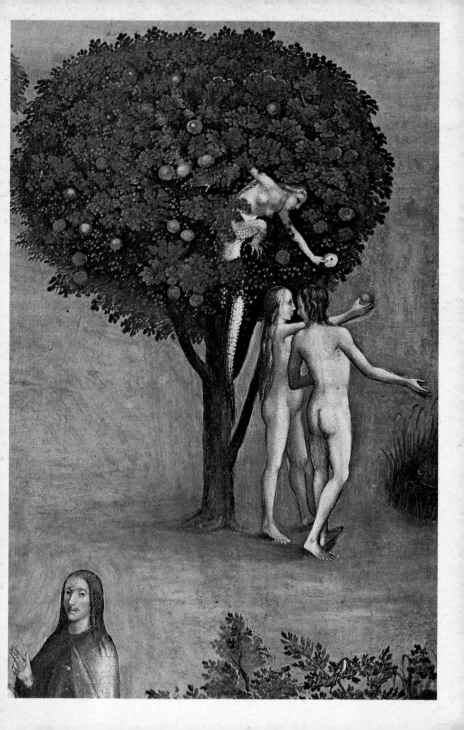

1510–1516

***THE EPIPHANY
TRIPTYCH
(ANDERLECHT)***
Anderlecht (Brussels),
Church of St Peter and St
Guyon
63A St Peter
Oil on panel/80.5 × 26.5/
63B St Mary Magdalene
Oil on panel/80.5 × 26.5/
63C St Joseph
Oil on panel/80.5 × 26.5/
***63D The Adoration of the
Magi***
Oil on panel/78 × 62/
63E The Retinue of the Magi
Oil on panel/80.5 × 26.5/

***64A–C The Adoration of the
Magi***
Oil on panel/?/
Upton House, nr. Banbury,
Bearsted Collection

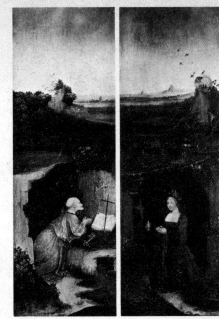

63A 63B

64A

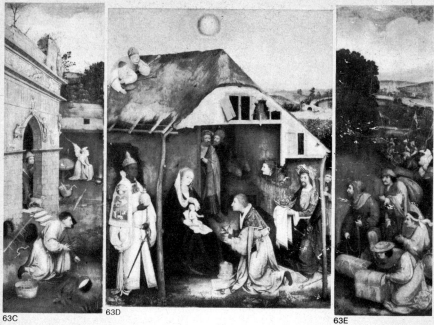

63C

63D

63E

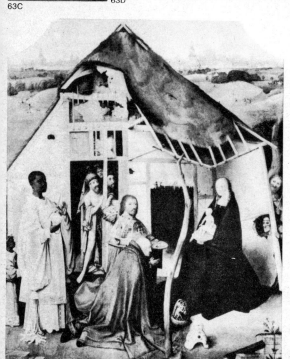

64C

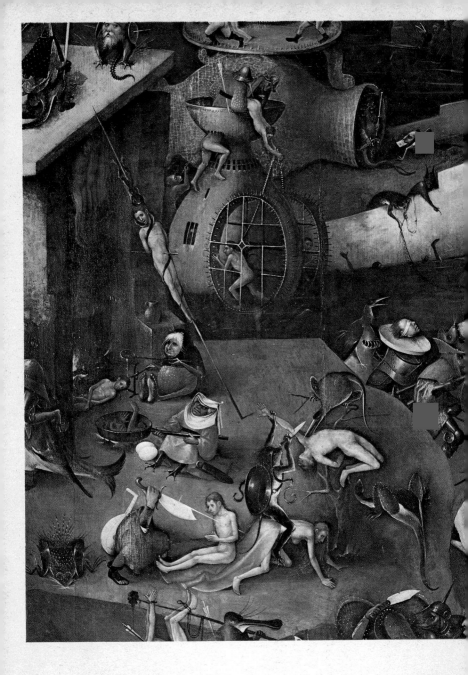

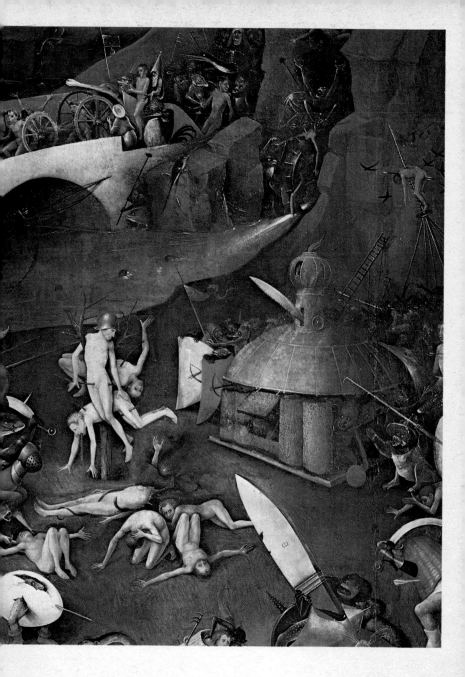

The Last Judgement Triptych, Vienna (No. 50D; detail).
THE VISION OF TONDALUS *and the* CALENDRIER DES BERGERS *have been identified as the literary sources for the colourful torments to which the damned souls are subjected here.*

**THE ADORATION
TRIPTYCH**
(Kleinberger-Johnson)
**65A The Adoration of the
Shepherds**
Oil on panel/33 × 21.6/
**65B The Adoration of the
Magi**
Oil on panel/70 × 42/
New York, Kleinberger
Gallery
65C The Retinue of the Magi
Oil on panel/33 × 21.6/
Philadelphia, Museum of Art
(Johnson Collection)

66 The Adoration of the Magi
Oil on panel/182.8 × 142.2/
New York, Metropolitan
Museum

65A

65C

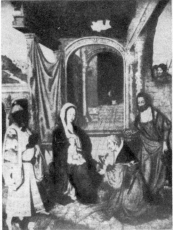

65B

**The Last Judgement Triptych,
Vienna (No. 50D; detail).**
*The triptych's composition and
details follow the pattern of
Bosch's early works while the
pictorial language is that of his
full maturity.*

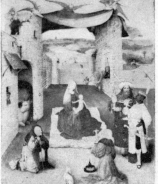

66

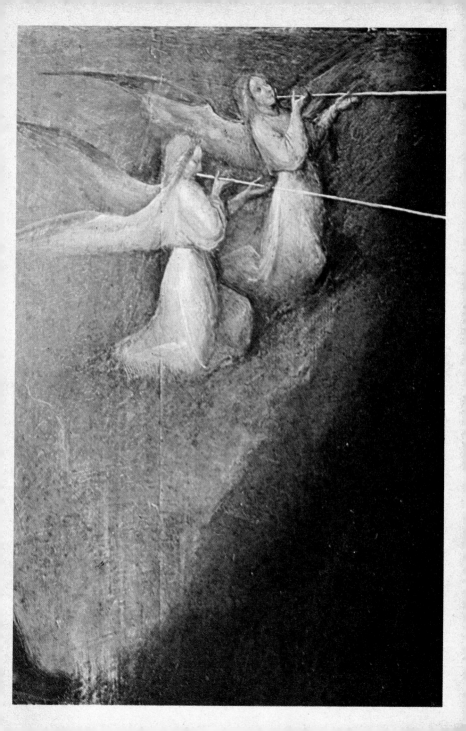

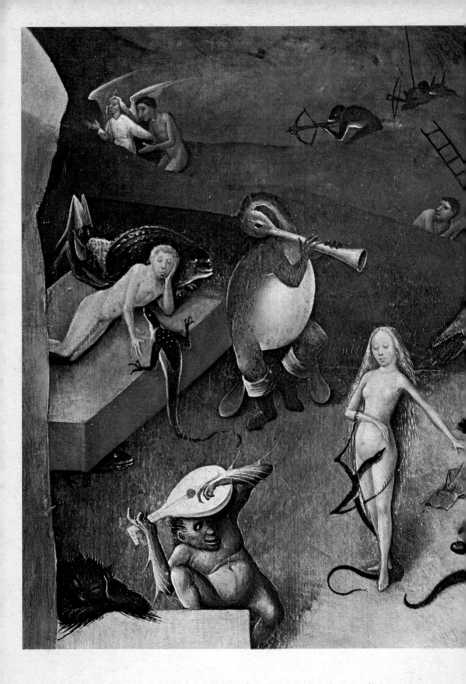

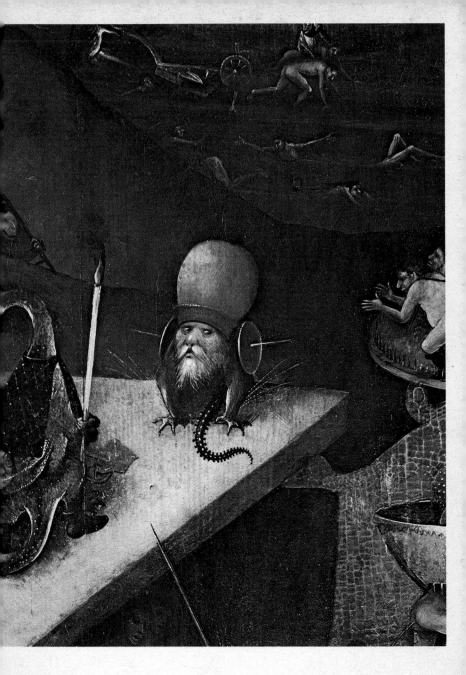

The Last Judgement Triptych, Vienna (No. 50D; detail).
One of Bosch's strangest images: the so-called 'gryllos', monstrous figures, half-human, half-beast, whose precursors date back to the Alexandrian age.

1510–1516

67A Virgin and Child
Tempera on canvas/
247.5 × 84/
67B St John the Evangelist
Tempera on canvas/
247.5 × 84/
's-Hertogenbosch, Cathedral

68 Christ before Pilate
Oil on panel/46.5 × 36.5/
Rotterdam, Museum
Boymans-van Beuningen
Probably a copy of a lost
original

69 Christ before Pilate
Oil on panel/84.5 × 108/
Princeton, Art Museum

Christ crowned with Thorns
(No. 57).
This is possibly one of the
earliest of Bosch's pictures
dealing with the Passion. His
use of half-figures gives
greater emphasis and sense of
immediacy to the subjects
portrayed.

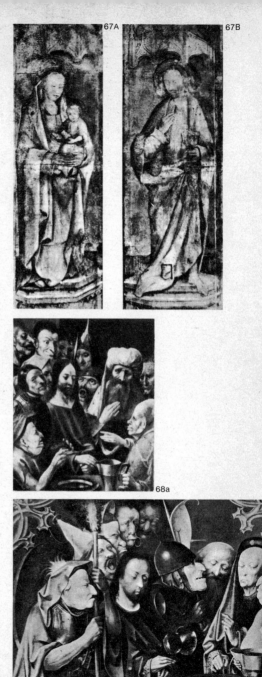

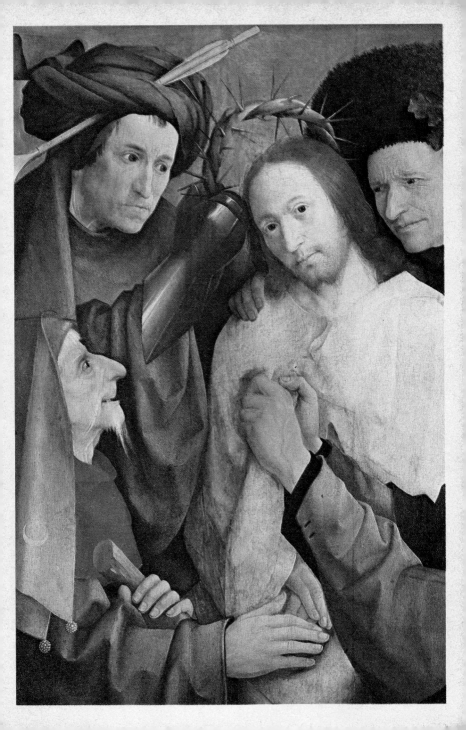

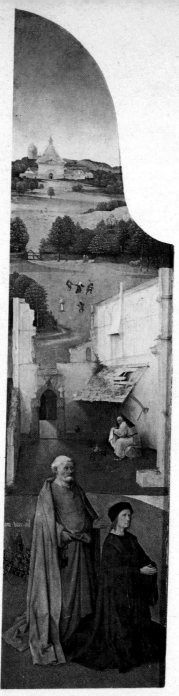

The Epiphany Triptych, Madrid (open) (No. 62 BCD). *Fourth and last of the great triptychs, this solemn composition makes use of many of the motifs found in Flemish painting, but presenting them in an entirely new light.*

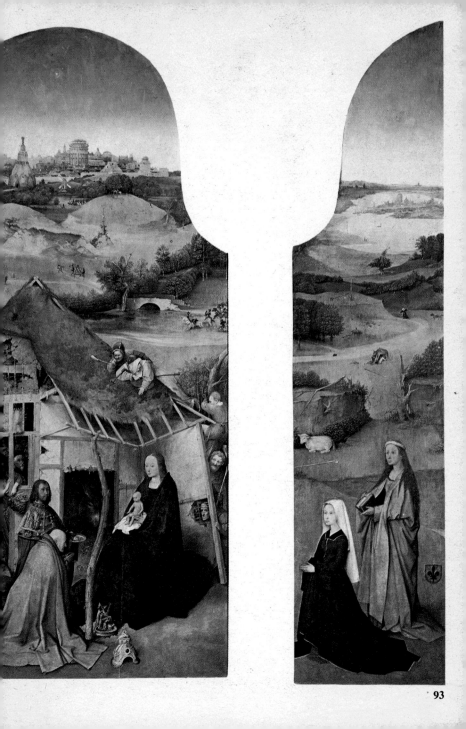

1510–1516

70 Christ bearing the Cross
Oil on panel/76.5 × 83.5/
Ghent, Musée des Beaux-Arts

71 The Kiss of Judas
Tempera on panel/
50.8 × 80.3/
San Diego (California), Fine
Arts Gallery
Probably a copy of a lost
original

72 Christ before Pilate
Oil on panel/29 × 74/
São Paulo, Museu de Arte

73 The Purging of the Temple
Oil and tempera on panel/
102 × 155.5/
Copenhagen, Statens
Museum for Kunst

70

71a

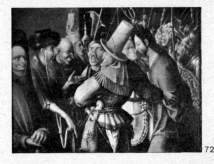

72

73

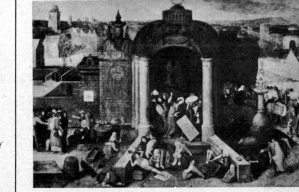

*The Epiphany Triptych,
Madrid (No. 62C; detail).*
*The atmosphere of suspense
suggests the liturgy of the
eucharist which in Flemish
painting is often linked with
the theme of the Adoration of
the Magi.*

94